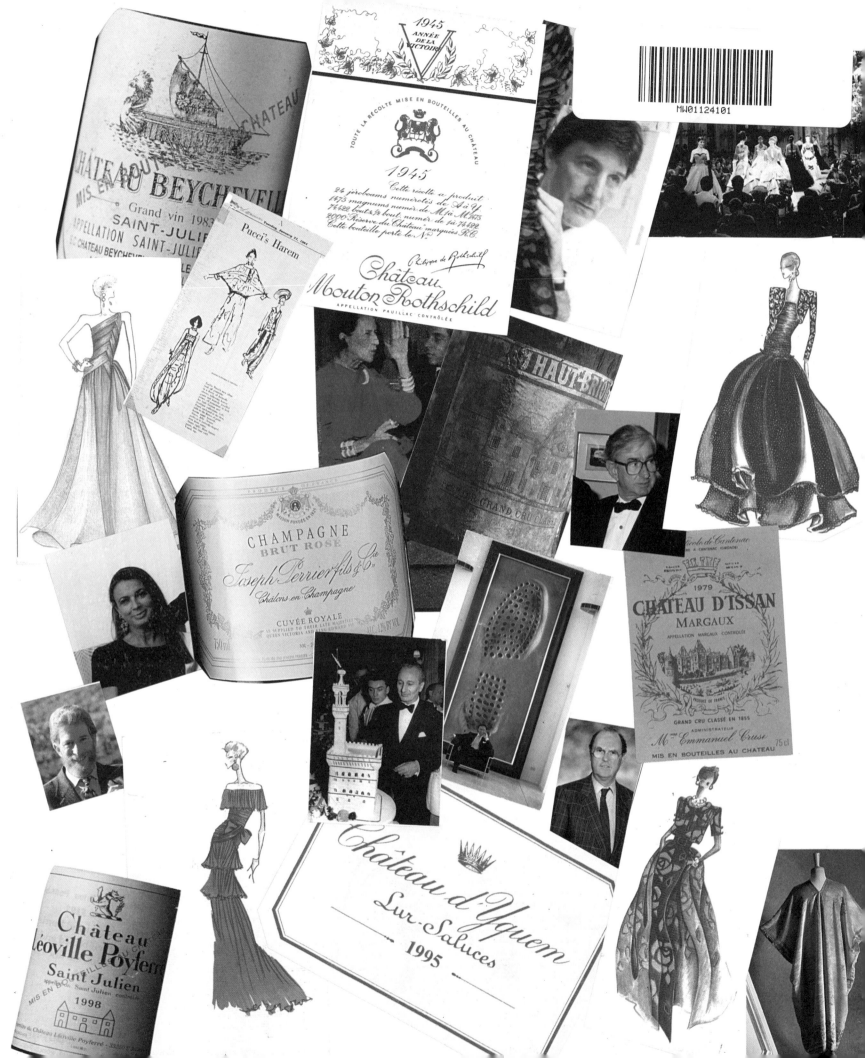

Taste the FASHION

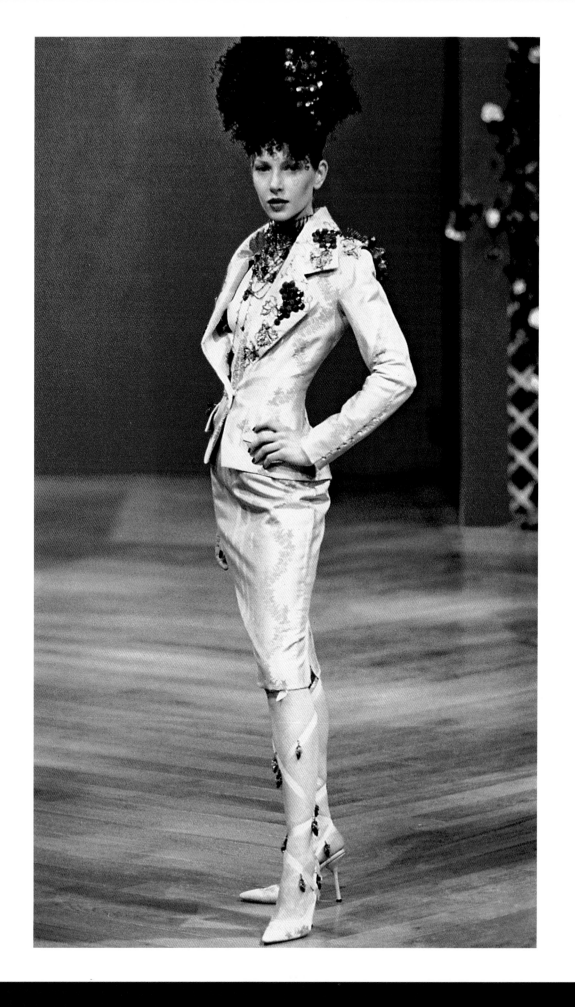

Paola Buratto Caovilla

Taste the FASHION

A celebration of luxury and creativity

SKIRA

Design
Marcello Francone
with Simona Frigerio

Editing
Emanuela Di Lallo

Translation
Tim Stroud

Cover Photo
Amendolagine e Barracchia

A special thank to Bibi Frusciante
d'Angiolino for her precious help

The author is at the disposal of the
entitled parties as regards all unidentified
iconographic and literary sources

First published in Italy in 2001
by Skira Editore S.p.A.
Palazzo Casati Stampa
via Torino 61
20123 Milano
Italy

Printed and bound in Italy.
First edition

ISBN 88-8491-104-4

Distributed in North America and
Latin America by Rizzoli International
Publications, Inc. through St. Martin's
Press, 175 Fifth Avenue, New York,
NY 10010.
Distributed elsewhere in the world
by Thames and Hudson Ltd.,
181a High Holborn,
London WC1V 7QX, United Kingdom

Particular thanks to
Alfredo Antonaros
Luciano Benetton
Luciana Boccardi
Pier Luigi Bolla
Mario Boselli
Cesara Buonamici
Franco Cologni
Sibilla Della Gherardesca
Walter Filiputti
Nathalie Grenon
Katell Le Bourhis
Raffaello Napoleone
Carlo Nordio
Agostino Ropolo
Judy Rudoe
Wilma Sarchi
Fabio Scarpitti
Giuseppina Viglierchio

Paola Buratto Caovilla would like
to express particular gratitude to LVMH
for their valuable help

Dedicated
to everyone who appreciates beauty,
quality and luxury.
And knows how to enjoy it.

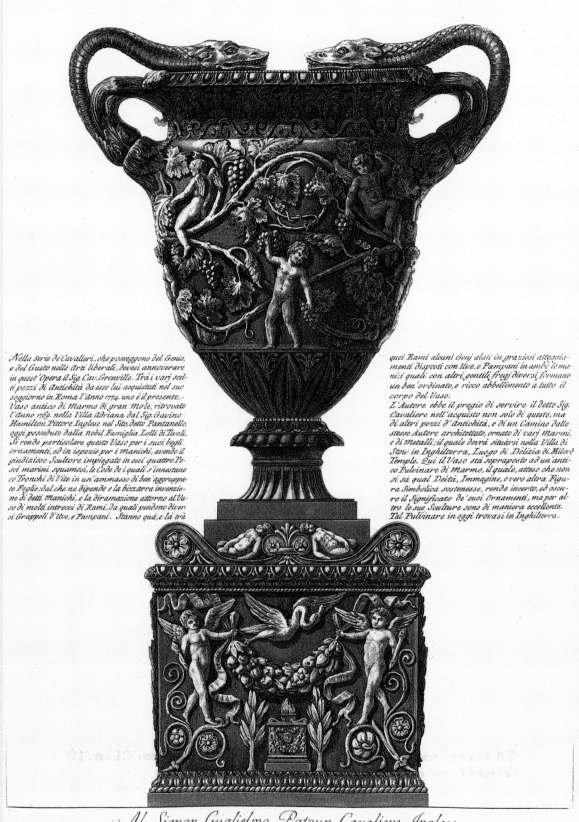

Nella Serie de'Cavalieri, che posseggono del Genio, e del Gusto nelle Arti liberali, devesi annoverare in quest'Opera il Sig. Cav. Grenville. Trà i varj scelti pezzi di Antichità da esso lui acquistati nel suo soggiorno in Roma l'Anno 1774. uno è il presente. Vaso antico di Marmo di gran Mole, ritrovato l'Anno 1769. nella Villa Adriana dal Sig. Gavino Hamilton Pittore Inglese nel Sito, detto Pantanello, oggi posseduto dalla nobil Famiglia Lolli di Tivoli. Si rende particolare questo Vaso per i suoi begli ornamenti, ed in ispezie per i manichi, avendo il giudizioso Scultore impiegato in essi quattro Pesci marini squamosi, le Code de i quali s'innestano co'Tronchi di Vite in un'ammasso di ben'aggruppate Foglie; dal che ne dipende e la bizzarra invenzione di detti Manichi, e la diramazione attorno al Vaso di molti intrecci di Rami, da quali pendono diversi Grappoli d'Uve, e Pampani. Stanno quà, e là trà

quei Rami alcuni Genj alati in graziosi atteggiamenti disposti con Uve, e Pampani in ambi le mani; i quali con altri gentili fregj diversi, formano un ben ordinato, e ricco abbellimento a tutto il corpo del Vaso.

L'Autore ebbe il pregio di servire il detto Sig. Cavaliere nell'acquisto non solo di questo, ma di altri pezzi d'Antichità, e di un Camino dallo stesso Autore architettato, ornato di varj Marmi, e di Metalli; il quale dovrà situarsi nella Villa di Stow in Inghilterra, Luogo di Delizia di Milord Temple. Qui il Vaso sta sopraposto ad un antico Pulvinare di Marmo, il quale, atteso che non si sà qual Deità, Immagine, o vero altra Figura Simbolica sostenesse, rende incerto, ed oscuro il Significato de'suoi Ornamenti, ma per altro le sue Sculture sono di maniera eccellente. Tal Pulvinare in oggi trovasi in Inghilterra.

Al Signor Guglielmo Patoun Cavaliere Inglese
Amatore delle belle Arti

In atto d'Ossequio Il Cavalier Gio: Batta Piranesi D. D. D.

Cav. Piranesi F.

THOUGHTS ON FASHION AND WINE.
MYTH, TRADITION, CULTURE AND SEDUCTION:
THE WORLDS OF WINE AND FASHION HAVE MANY THINGS

IN COMMON, BUT IT IS THE REFERENCE TO THE SEASONS

that perhaps best sets them apart. For Wine, it is the ceaseless cycle of nature, the annual reproduction of plants conditioned by the clemency of the weather and the power of the sun, and by interaction with both helpful insects and those feared like the plague. For Fashion, it is the requirement — utterly human but very whimsical in nature — that every six months there are new gems, new fruits and new crops. This is a skilful caprice, the artificiality of which is seen to be even more evident today as the autumn/winter and spring/summer distinctions become increasingly faint, mitigated by global warming, indoor heating, air conditioning and other technologies that make our lives more comfortable, but also more uniform. It was to break this uniformity, to make us dream and feel freer and more independent of nature that Fashion was born. Fashion is one aspect of the contemporary world that lies at the centre of planet-wide public and media attention. But it has only recently found itself to be an autonomous, creative language while contemporaneously at the meeting point of a series of various disciplinary interests: art, design, sociology, anthropology, science, economics, show-business, sport and communications. This has made Fashion a cultural entity but also a research laboratory that symbolises our post-modern era. Wine is a cultural product as well, and it is equally analysable from many points of view, but it is also something that has a history of several thousands of years. It is linked to the history of civilisation (in particular to the history of the Mediterranean) and good food, and to the natural and local dimension of the *terroir* of each genuine agricultural activity. Wine has always been aware of the enormous extent of the culture that lies behind it. On the one hand, it referred this culture to the traditional and popular dimension of customs, values and daily pleasures often coloured by the picturesque: straw flasks, jolly hostelries and blow-out meals. On the other hand, it associated the culture of Wine-making with an elegant life of sophisticated tastes and esoteric knowledge restricted to a small circle of connoisseurs, of men and women of the world, who ate at tables covered with Flanders linen and who were familiar with the uses of glasses of every shape and size. Only recently has Wine learned to do away with the conflicting positions of the cultured and the uncultured: the two extremes of good living. Fashion did it some time ago; it was the Italians who were the first to offer it, fifty years ago, as something more than and different to the simple, anonymous standardised clothing available, while still being distinct from the old and aristocratic Haute Couture. This was the beginning of the international novelty of high quality, ready-to-wear Italian Fashion. Just as for Wine, the watchword (the only one) for Fashion has always been and today still is: quality. Wine and Fashion are both essential elements in the contemporary quality of life, the more modern, open and deeper version of luxury. It is not simply by chance that Italy and France are the world leaders in both fields.

MARIO BOSELLI
President of Pitti Immagine

Together to fashion Beauty

A single common denominator is shared by all things of Beauty.
A single philosophy
unites two different but similar worlds.
2000 years of history have been absorbed in the development
of elegant and innovative modernity.

FASHION & WINE

IF HISTORIANS AND PHILOSOPHERS

EVER TAKE AN INTEREST IN US AND OUR TORMENTED

BUT FASCINATING ERA, THEY WILL BE SURPRISED AT THE NEED TO ASSIGN

a major role to man, to the individual, and to his imagination and creativity, in their analysis of the era of the explosion in technology. Our age seems to relegate

to the role of a tool what technology, though we control it, gives us; we used to think technology was a bringer of intelligence, when it is in fact simply an ex-

pression of diligence. If well programmed, machines are diligent, but only man is intelligent and creative, and is able to increase the value of objects as a result of

his imagination and cultural riches. The purpose of this prelude is to take us into the future world of *homo sapiens* in the third millennium. In spite of the ex-

plosion in technology that is taking place, he is still far from the *homo faber* that has preceded him. We therefore enter an area of great values — not just moral

but also historical and cultural — that mark every part of our everyday life in the modern era. It is only this rather broad view that allows us a correct and sure

evaluation of the behaviour and tendencies of everyday life. The phenomenon of Fashion — which forms the central theme of this book — represents that so-

cial and psychological reality that can be summarised in one word: seduction. Seduction is the pillar that supports the complex construction of Fashion's global

success. This globality is, in fact, a volcanic phenomenon, but one that could verge on dissoluteness if understood incorrectly or interpreted poorly. It tends to

reduce everything to uniformity and it is therefore vital to defend its diversity. Hidden in the balance of uniformity vs. diversity lies the secret of Italian Fashion's

world-wide success. Beautiful fabrics can be produced by anyone and desired by anyone, but they take on a different dimension and allure when they are en-

hanced by artistic creativity, often of genius. The result is a blend of the physical characteristics of the raw material and the intangible flair of art and design. This

is when beauty is imbued with the capacity to tempt and to seduce, properties that are not static but which glow and evolve, properties that cannot be standard-

ised or defined, let alone patented. These same qualities are also to be found in the world of great Wine because the hand of man plays a fundamental and cre-

ative role here too. The beautiful fabrics are in this case the grapes, and they too can be nearly always of good quality, but what makes the difference is man, with his ability to create, enhance and refine, without allowing himself to be overly conditioned by the pressure of tradition. The traditional value system of agricultural civilisation is no longer sufficient by itself to give the consumer confidence in Wine, nor is the long established regard in which Wine used to be held. Today Wine must be fuller, better blended, more elegant and, above all, more friendly. In short, it must have the capacity to tempt and seduce. The world of wine is subject to forces that risk standardising flavour, through the poorly understood process of homogenisation, partly because the phenomenon of the "democratisation of taste" is currently stronger than ever, though this phenomenon is nothing more than the raising of the cultural awareness of the consumer. The identity and diversity of Wine are therefore of major importance if it is to achieve the global success enjoyed by Fashion. Fashion and wine share an affinity in that both must tempt consumers before being able to convince them. We wear clothes by a famous designer because we have been tempted and because, in turn, we wish to seduce. Exactly the same process operates with Wine. Today we do not drink Wine for reasons either of nourishment or to slake our thirst: instead, we do so because it is one more way of losing ourselves in the sensual labyrinth of hedonism. This great change in Italian wine has taken place over the last thirty years, somewhat akin to what has happened in Fashion, and it is to the great merit of Italy's best Wine-producers that they have succeeded in convincing not only the home market, but also the foreign one, of the great quality and symbolic value of modern Italian Wine. As the industry affects almost two million families, it is a social reality of key importance. Like Fashion, from a merely economic viewpoint it has a considerable annual turnover. The bottled temptation that we export represents almost 260 million euros but also increases land reclamation and the turnover of the food and wine tourism industry, another handsome return. The development of Italian Wine over the last thirty years is not disassociated from the period that the Vinitaly trade fair has been in existence. Both in Italy and, over the last few years, abroad, Vinitaly has had a practical involvement in this process. Statistics are decidedly eloquent, and the role of Vinitaly — the largest and most visited wine fair in the world — corresponds to that of Italy as a whole, which is the largest national wine-producer in the world. Wine does not only generate material well-being and wealth: it produces prestige and helps to create a particular image. It is for these reasons that VeronaFiere is fully supportive of the publication and distribution of this book. As an expression of Italian culture and art, it provides an exhaustive representation of Italy, its Fashion and its Wine.

PIER LUIGI BOLLA

President of VeronaFiere

"Mon rôle est de séduire"

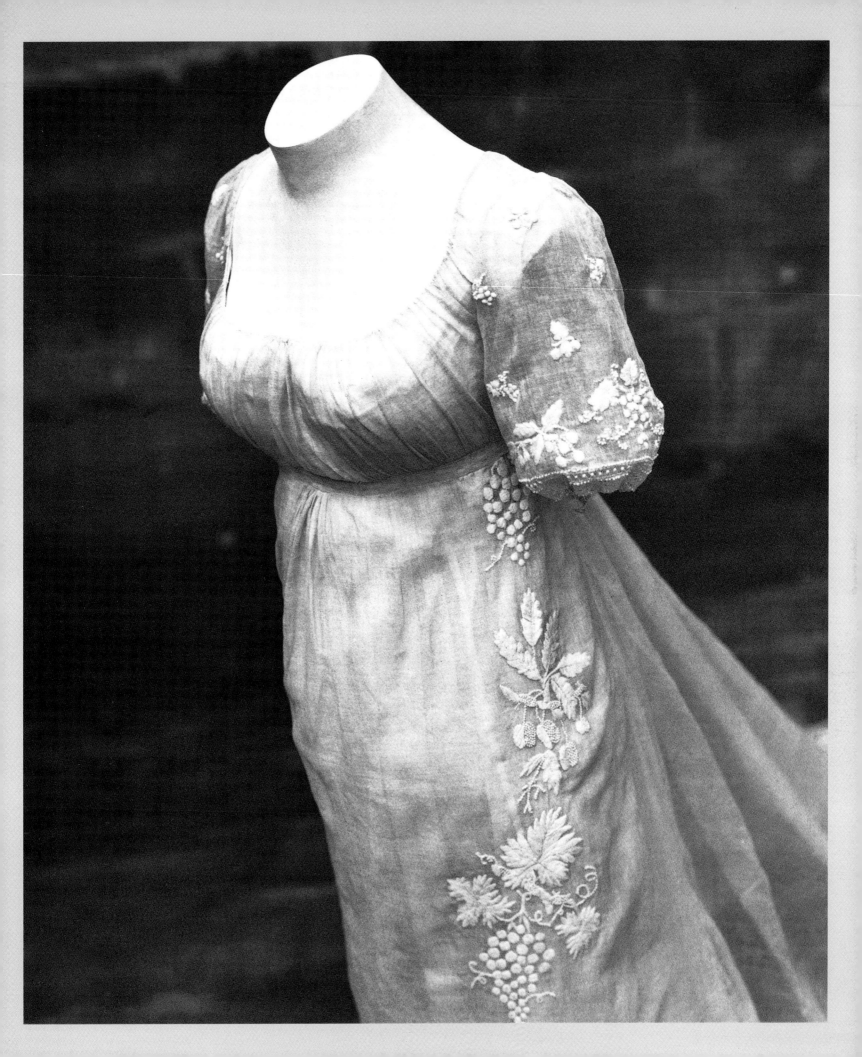

HISTORY

THE BIBLE SAYS THAT NOAH WAS THE FIRST PERSON TO SQUEEZE THE JUICE

from grapes and make wine, but the classical Greek world attributes that invention to Dionysus — the god of joy, youth and the theatre — with his retinue of satyrs. In the Latin world, Dionysus was transformed into Bacchus and, in the Etruscan world, into Fufluns. The euphoria created by wine encourages one to greater appreciation of the joy of living and poetry, and to the giving of friendship, affection and love. Bread, wine and oil formed the basis of daily nourishment, and were the rations given to the Roman legions, without meat. Italy, also known as Enotria ("land of wine"), is able to boast one of the longest established wine-making practices in the world; in Roman times there were already roughly one hundred different types of wine. Wherever they went, Roman occupying troops attempted to cultivate vines for their own subsistence: in Spain, Pontus, Syria, England, Germany and France, and often they achieved remarkable success. However, their method of making wine was not clear although ancient texts indicate that their wine was difficult to conserve unless it was condensed, cooked or various ingredients were added. Cato and Columella, in their works *De agricoltura*, refer more often to how it is possible to regenerate or conserve wine than they explain how to produce it. Italy is therefore the mother of all European wines. The barbarians — Attila at the head — made their camp fires with the wood of vines in the territories they devastated, but, based on the evangelical propaganda of the wedding in Cana, the monks in the monasteries distributed vines throughout the Italian peninsula and began to consider wine in high regard, such that the range of wines in the Italian states was already substantial in the Renaissance, and with particular species of vine in each latitude. During periods when spices were freely available, perfumed and sweet wines were very popular, but the common people generally drank their wine dry and bit-

THE TWO-FACED
JANUS

ter at mealtimes with their bread. As a general rule, each region drank its own wines and it was only rarely that they were sold beyond the borders of each zone or country. Old wine — always red, of a certain strength and kept in dusty bottles — was a favourite, but so was young, fresh wine sold in and poured from flasks. During the eighteenth century, France had achieved the respect even of Italy with its Burgundies and Champagnes, while the Italians, in Veneto in particular, could only counter such quality with wines enjoyed by the Hapsburg imperial family, such as Picolit, which today has almost disappeared. Piedmont, on the French border, with its Barolo and the sweet Moscato d'Asti, had already acquired a certain enological dignity that could be coupled with respectable cooking, but in every other zone of Italy, the local foods were justly combined with local wines, thus turning the peninsula into a happy and ed-

ible patchwork of regions. Meanwhile, the little wine produced in France and even Germany was treated with great care, while in Italy, generous but unrefined wines were produced for the table. During the second half of the nineteenth century, powdery and downy mildew ruined Italian vines so that, in order to survive, cultures from American vines, known as "direct cultivators", were adopted. These produced particularly coarse wines but the people got used to them and even went as far as to consider them an expression of authenticity. Consider, for example, the love for certain lost wines in Veneto such as Clinton, Fragolino, Bacò and Corbinello. Later, after the Great War, the situation improved and a great many vines were imported from France to bring fresh "blood" to Italian production. At the same time, local wines were extolled and this combination of factors formed the basis for the enological situation in Italy today.

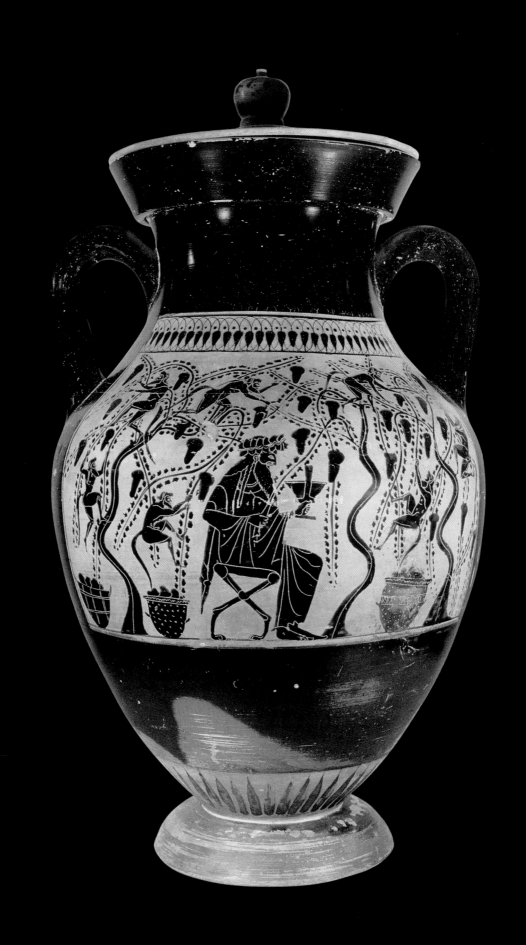

*I*t is a well-known fact that Sybaris was famous in Greek antiquity for its inhabitants' specialised and sophisticated ability to take pleasure to the limit. It was as a result of this capacity, as everyone knows, that luxury and drink taken to extremes became known as *sybaritism*.

It was not so much the cultural sophistication as the quality of the bacchanals which, originally simply for the tasting of wine, increased the appreciation of wine and made inebriation an exemplary expression of a convivial culture that celebrated truth.

In fact, talking about sybaritism corresponds to the discovery, in the drinking of wine, of the origins of a desire that is hidden within each one of us: the liberation from fear. With the cultivation of virtuous deeds, this desire for liberation destroys authenticity and relegates it to play-acting.

It can, therefore, be hypothesised that wine, when drunk to excess, eliminates inhibition and encourages the conquering of one's intentions by one's true nature. The simple fact of having intentions means one is play-acting and is never true to oneself!

"Quo magis tendunt ad esse, eo magis festinant ad non esse" (the more one tends to being something, the less one is actually what one wants to be), or so Augustine of Hippo defined and resolved the problem of lack of genuineness. The descent of luxury into the illusion of a dissolute, unbridled, yet subtle, bliss.

Desire found its easiest fulfilment in the naturalness of joyful and drunken behaviour which, in celebrating life, nourished dionysiacal conviviality.

The mention of Dionysus is not far-fetched. Immersing oneself in lasciviousness dulls the pain of losing oneself and is almost a melancholy anticipation of death.

"Desperantes semetipsos tradiderunt in voluptatem" (Who being past feeling have given themselves over unto lasciviousness, to work all uncleanness with greediness) as Paul of Tarsus summed up voluptuousness neatly in *Ephesians*, 4, 19. The giving of oneself over to pleasure is always based on evident or hidden desperation!

It was those in despair who abjectly abandoned themselves to voluptuousness. They abdicated themselves to enjoyment to follow the happiness identified with pleasure washed down with abundant quaffs of wine.

Originally it was a return to nature without the abandonment of culture: that is the factor that describes the world of the sybarite. *Sybarite culture*, because culture has always had a liberating role for man, rather than *sybaritism* which is decadence for its own sake. Sybarite culture was an upgraded version of "parrhesia", i.e. free-spokenness. Freedom therefore from the morbid universe of guilt, which is a deception and deceit for all humanity. And thus, from this view — not just purely orgiastic, of an orgy as an end in itself — of sybarite culture, one acquires a deep and guided motivation, sustained by aspiration, to achieve freedom in celebration.

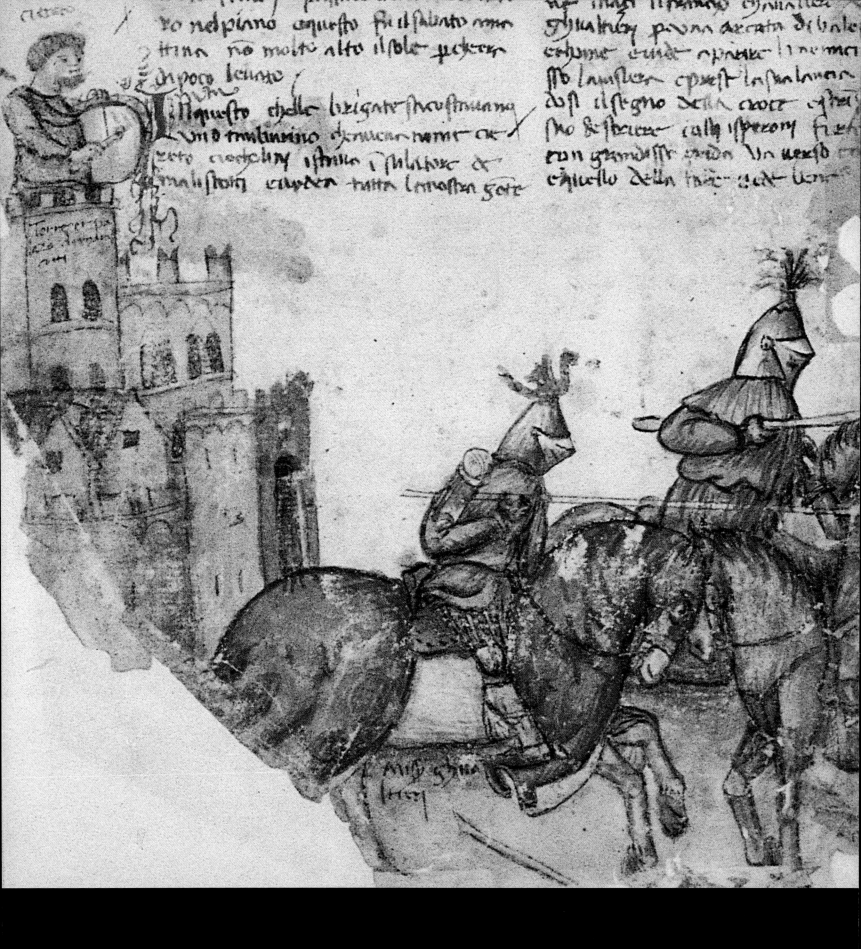

GIOVANNI DI VENTURA
THE BATTLE OF MONTAPERTI, 18TH CENTURY
Siena, Biblioteca Comunale

You cannot talk about Italian wine without referring to Chianti, and History will whisk you immediately to Montaperti in the luxuriant hills of Siena

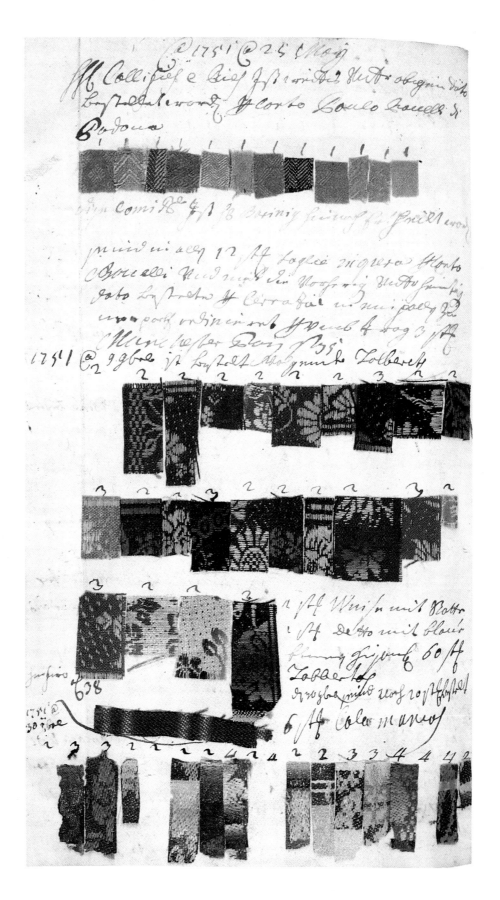

BOLZANO, 1749-1761

This book contains numerous samples from various places,
including Venice and other cities in the Veneto region.
Bolzano, Chamber of Commerce

THE MOST IMPORTANT
CIVILISATIONS IN ANTIQUITY
— FROM THE ARABIAN PENINSULA,
THE MIDDLE EAST, THE BANKS OF THE NILE

and the Mediterranean — had three things in particular in common: the ability to express concepts through signs (writing), the cultivation and cooking of cereals (bread) and the knowledge that allowed the production of drinks from fermented grapes (wine). Wine was never the only drink available in any of these civilisations but it was certainly the only one to have been used in religious and ritual ceremonies and that found a central position on the table as part of daily fare (with bread and oil) and on altars where liturgies were performed. Wine was certainly the only drink in Hebrew, Islamic, Christian and classical thought that maintained its metaphorical values, which, from time to time, linked it to blood, inebriation, strength, the spirit, friendliness and cheerfulness. "In vino veritas" is a common saying (it was also the title of one of the more cerebral works by the Danish philosopher, Søren Kierkegaard). But in addition to truth (pure, transparent and provoking because it is liberated from all inhibition, censure and qualms), wine hides much of Italian history.

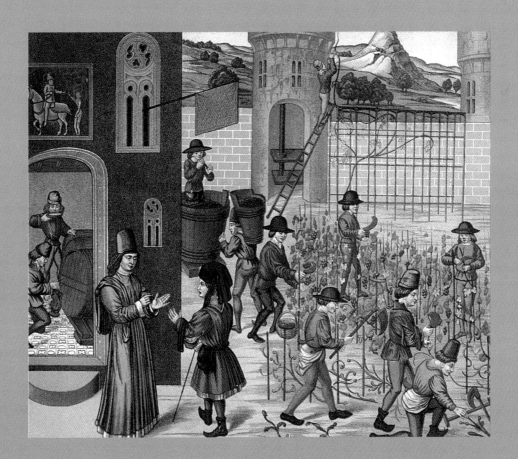

Dionysus, son of Zeus, delights in banquets: and his dear love is peace,
giver of wealth. Saviour of young men's lives — a god rare!
In wine, his gift that charms all griefs away,
alike both rich and poor may have their part.
His enemy is the man who has no care to pass his years in happiness and health,
his days in quiet and his nights in joy.
Watchful to keep aloof both mind and heart from men
whose pride claims more than mortals may.
The life that wins the poor man's mortal voice, his creed,
his practice — this shall be my choice.

PLATO

Wine to man is like water to the plants: in the right measure it keeps them erect,
but when drunk to excess, it makes them droop.

PINDAR

Wine raises the spirits and elevates thought and, in this manner,
worries are driven from the heart of man.

AESCHYLUS

Where there is no wine, there is no love,
nor do mortals have any other pleasure.

ARISTOPHANES

Wine comforts hope; and what would life be without hope?

Painting wine: sacred and profane art

Let's drink all this wine, today, to overcome all restraint,
all weariness and to stimulate our lust even more.
These are the requirements for a night of love: oil in the lamps and wine in the cups.

(APULEIUS, THE GOLDEN ASS)

TITIAN, BACCHANAL
Madrid, Museo del Prado

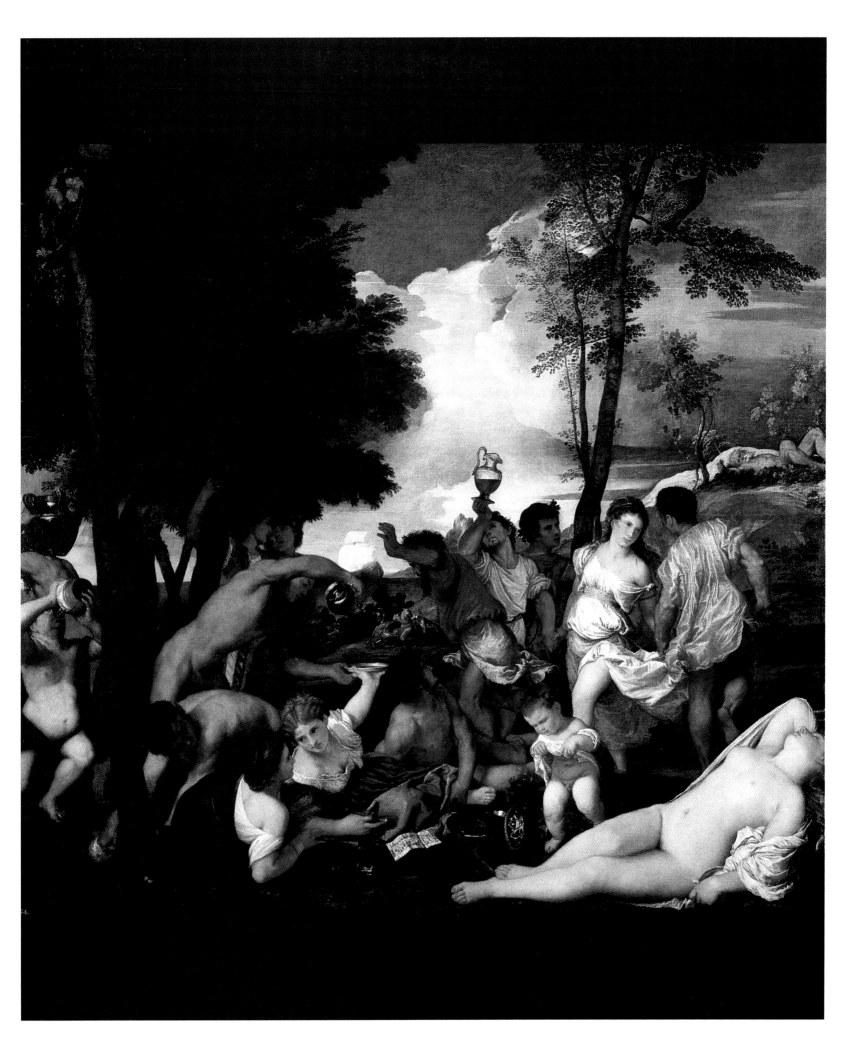

GO WHERE WINE TAKES YOU

WHOEVER IS FAMILIAR WITH WINE KNOWS THAT EVERY WINE WILL BRING A DIFFERENT SORT OF INEBRIATION. THERE IS THE HEADY, GRACEFUL AND VAPOROUS euphoria of champagne; the reveries induced by full-bodied and sincere reds that make your legs heavy and give wings to your thoughts; and there are the wines of freshly-pressed grapes that loosen the tongue and expand the heart: "New wine, new friend" claimed the *Ecclesiastes* happily. Every wine leads to a different experience and every bottle guards its magic secrets. This assortment of effects honours wine as one of the most divine of human inventions, but it also gives the drinker a particular responsibility. Knowing which wine is suitable to a particular moment (not just which wine is suitable to the food) is a not unexceptional skill in savoir vivre. Good taste is called that for a reason, rather than, for example, good touch or good sight. And there is nothing else that, like wine, makes reference to all the subtleties, nuances and acrobatic abilities of inquiry, distinction and classification that this sense has, whose organs coincide, curiously, with those responsible for language: lips, tongue, palate and throat all play their part in the savouring of wine. And this is a confirmation, as though one were needed, of the importance of drinking as a form of communication with others. "Libiam ne' lieti calici" (Let us drink from wine cups overflowing) sing Violetta and Alfredo in *La Traviata*; and, on the wings of the toast they make, their love takes wing. Over the course of time, wine has always been associated with jewellery and clothes, an opportunity for a playful encounter between luxury and fashion. The only difference is that, once the wine has been drunk, it becomes no more than a memory whilst the other two remain as part of history. All this is to say that fine clothes, lovely jewellery and good wine tend to be found together and to gratify the same bodies. Just as for wine, also clothes and jewellery are able to produce different effects and emotions as a result of their materials, colours and shapes and, to an even greater extent, an indefinable but no less tangible power of seduction. And, just like wine, clothes and jewellery are fundamental means of social expression, though with a difference: wine, strongly associated with sociability, also has a non-conventional and potentially transgressive power, a visionary and irrational ambition. Wine takes us where we want to go, it is only a question of scale. "The first glass", said Apuleius, "is to slake thirst, the second brings good cheer, the third sensuality, and the fourth foolishness". If three glasses seem too much, drink the fourth, and you will have an entire universe to explore, where you will discover luxury and fashion or, as Baudelaire wrote, Peace and Sensual Indulgence, i.e. Bacchus asleep and Venus consenting.

FRANCO COLOGNI

CARAVAGGIO, MAGDALEN PENITENT, DETAIL
Rome, Galleria Doria Pamphilj

Let us drink! Why wait for the lamps? There is only a sliver of daytime left.
Friend, get down two large cups: Dionysus gave men wine so they could forget their ills;
mix them in proportion of one to two, fill the cups to the brim, and let one chase the other away.

ALCAEUS, EXCERPT 346 V

Thy breasts shall be as
clusters of the vine,
the perfume of your breath
like cedar
and the roof of thy mouth, like excellent wine,
for my beloved, that goeth down sweetly,
causing the lips of those that are
asleep to speak.

SONG OF SONGS (7, 9-10)

Rodomonte was not used to wine,
because the law prohibited and damned it:
and when he tasted it, it seemed divine liquor,
better than nectar or manna;
and, in the Saracen fashion,
he downed great cups and full flasks.

LUDOVICO ARIOSTO, ORLANDO FURIOSO,
XXIX, 22

What is in question is the wine, the intellectual part of the meal.
Meat only represents the material part.

ALEXANDRE DUMAS

And that thou less may wonder at my word,
Behold the sun's heat, which becometh wine,
Joined to the juice that from the vine distils.

DANTE ALIGHIERI, DIVINA COMMEDIA,
PURGATORY, XXV, 76-78

They gave both the wine from a barrel to try,
and asked their opinion on its condition, its quality, its goodness or defects.
One tried it with the tip of his tongue, the other only waved his nose at it.
The first said that the wine tasted of iron;
the second said that it smelt rather of leather.
The master assured them that the barrel was clean and that that wine
had not known any tanning that could have provoked the taste of either iron or leather.
Nonetheless, the two experts confirmed what they had said.
Time passed, the wine was sold and, when the barrel was cleaned once more,
a small key was found hanging from a strip of leather.
This was because your Lordship might see if those from that race
are really able to give their opinions on such questions.

MIGUEL DE CERVANTES, DON QUIXOTE

FERRAGAMO

"Le bon Abbé se loue de son vin
et en use plus continuellement que nous ne faisons des eaux;
il ne met point d'intervalle à cette cordiale boisson,
et vous lui avez appris à n'y point faire de mélange."

Il me souvint dans ce moment de ces contes qu'on fait aux enfants,
de collations servies comme cela par des gens inconnus,
et puis des bras, des têtes, des jambes et tout le reste du corps
qui tombent par la cheminée, dont il se forme des personnes qui,
après avoir bu et mangé, disparaissent.

BUSSY-RABUTIN

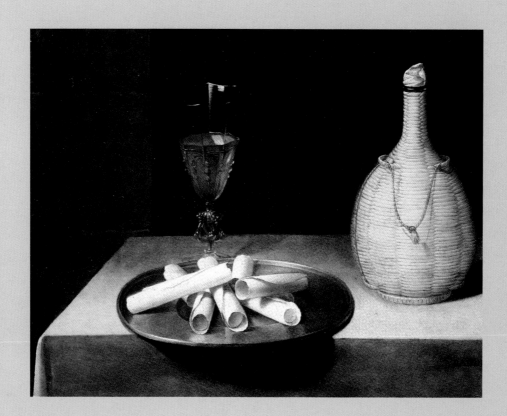

LUBIN BAUGIN, DESSERT DE GAUFRETTES
Paris, Musée du Louvre

From the Middle Ages to the Renaissance: survival and rebirth of the vine

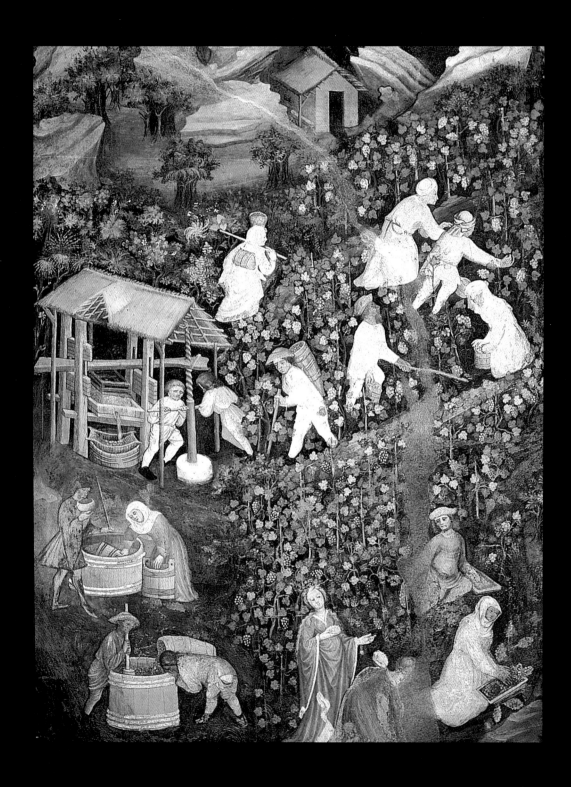

The month of October, from the cycle of the Months in the Aquila Tower in the Castello del Buonconsiglio.
The frescoes in this cycle (dating from the end of the fourteenth century) are dedicated to work during the months of the year.
Here we see the activities that are typical of October:
the grape harvest, transportation of the grapes, pressing, and tasting of the must.
Trento, Castello del Buonconsiglio. With permission from the Castello del Buonconsiglio, Monumenti e collezioni provinciali, Trento

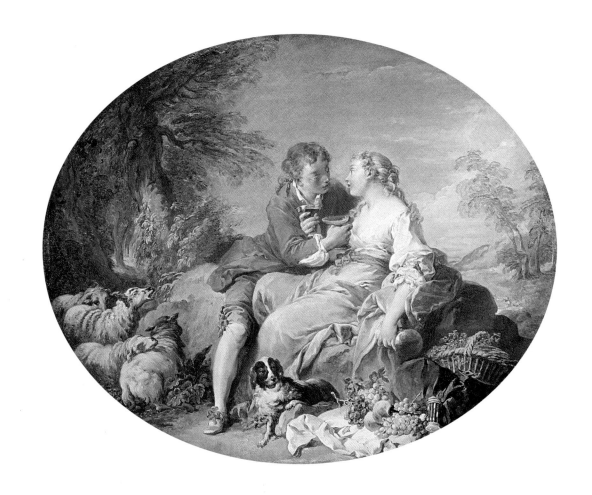

FRANÇOIS BOUCHER, PASTORAL
St. Petersburg, Hermitage Museum

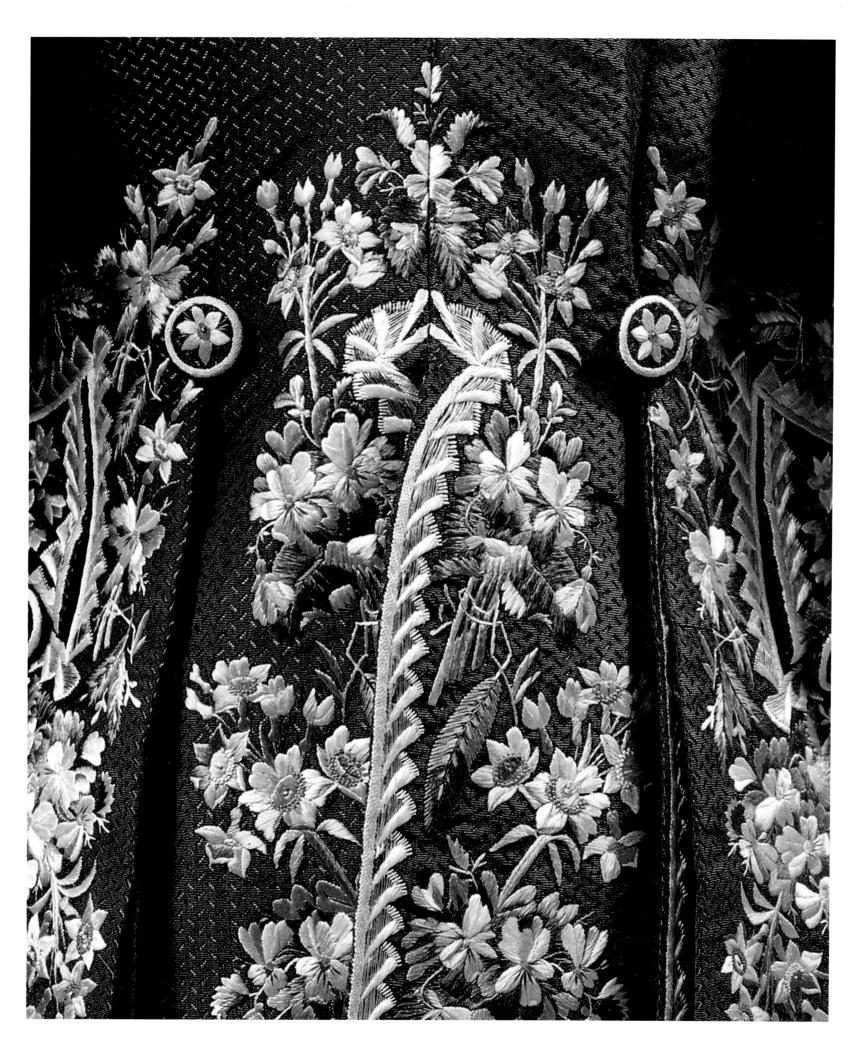

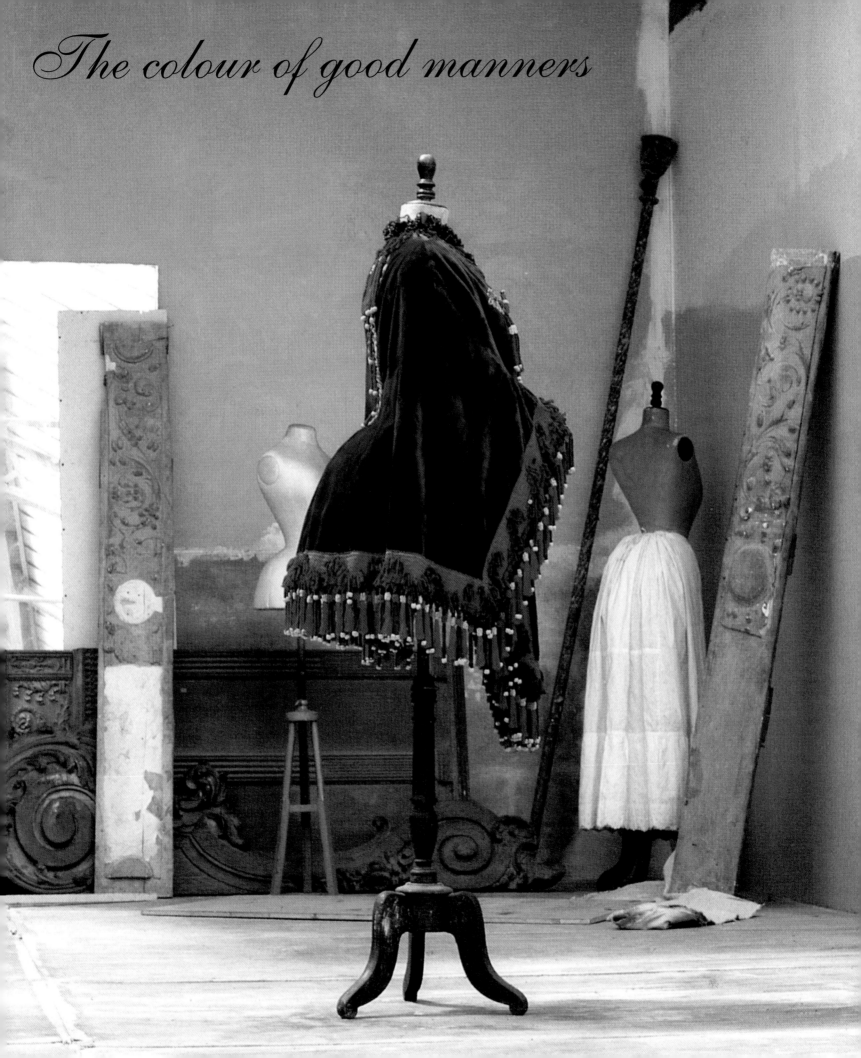

The colour of good manners

THE MEETING BETWEEN

BARON RICASOLI AND

KING VITTORIO EMANUELE II

AT BROLIO. AFTER YEARS OF RESEARCH

and experimentation, Baron Bettino defined the blend of grapes to produce Chianti Classico which, almost a century lat-

er, was used to regulate production of one of Italy's most famous wines, and which has remained in force to the present day.

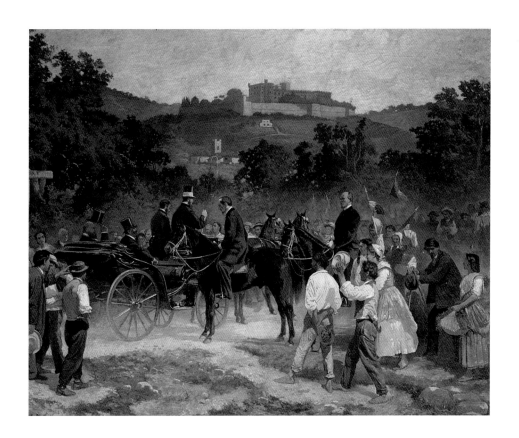

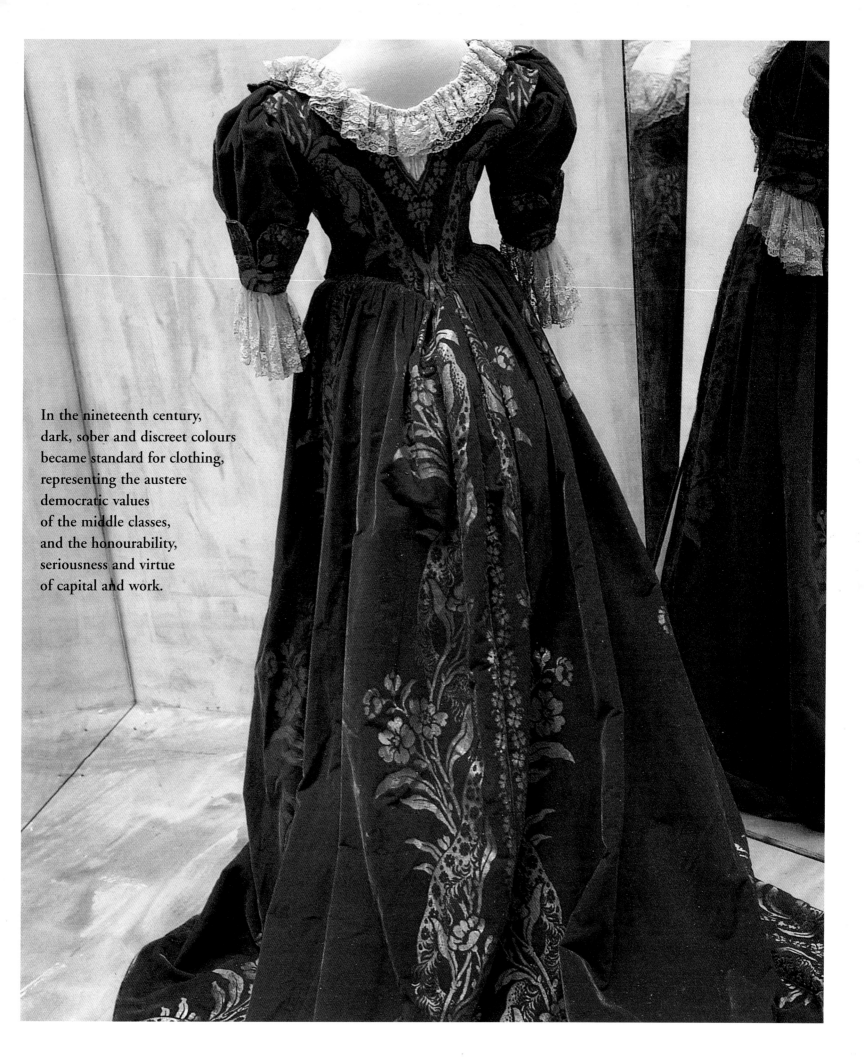

In the nineteenth century,
dark, sober and discreet colours
became standard for clothing,
representing the austere
democratic values
of the middle classes,
and the honourability,
seriousness and virtue
of capital and work.

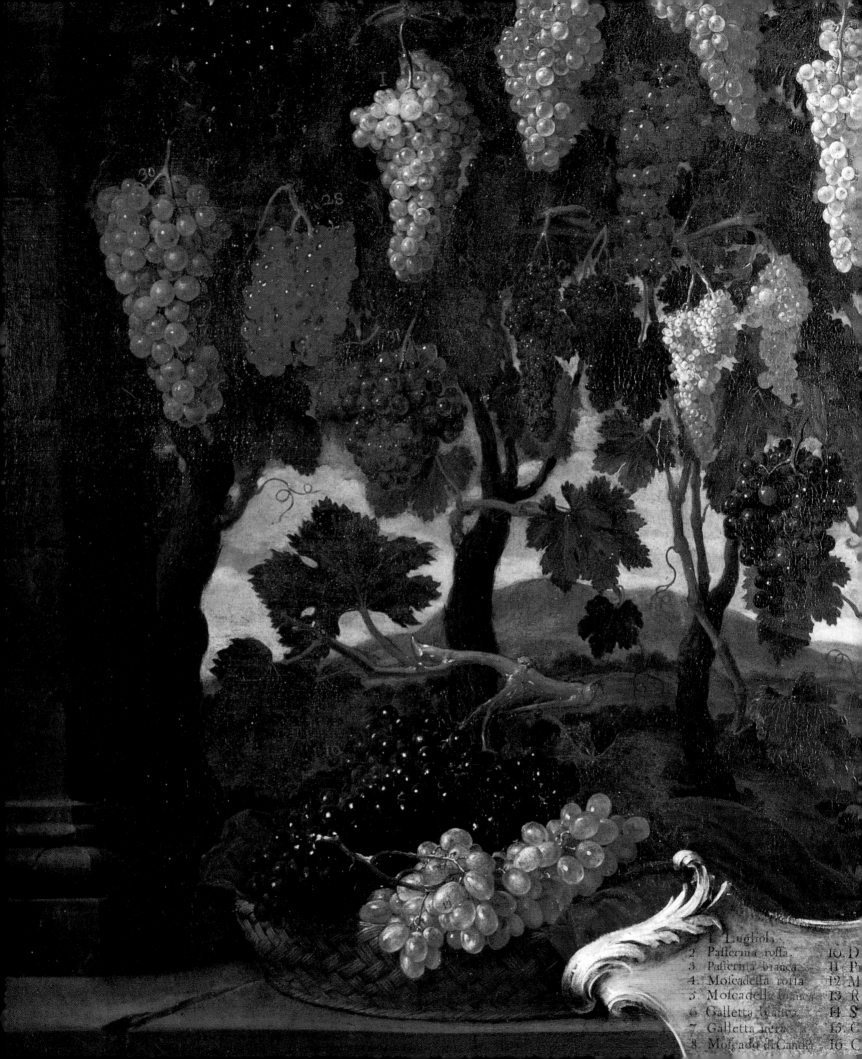

1. Lugliola.
2. Passerina rossa.
3. Passerina bianca.
4. Moscadella rossa.
5. Moscadell...
6. Galletta bianca.
7. Galletta nera.
8. Moscado di Candia.

10. D
11. P
12. M
13. R
14. S
15. C
16.

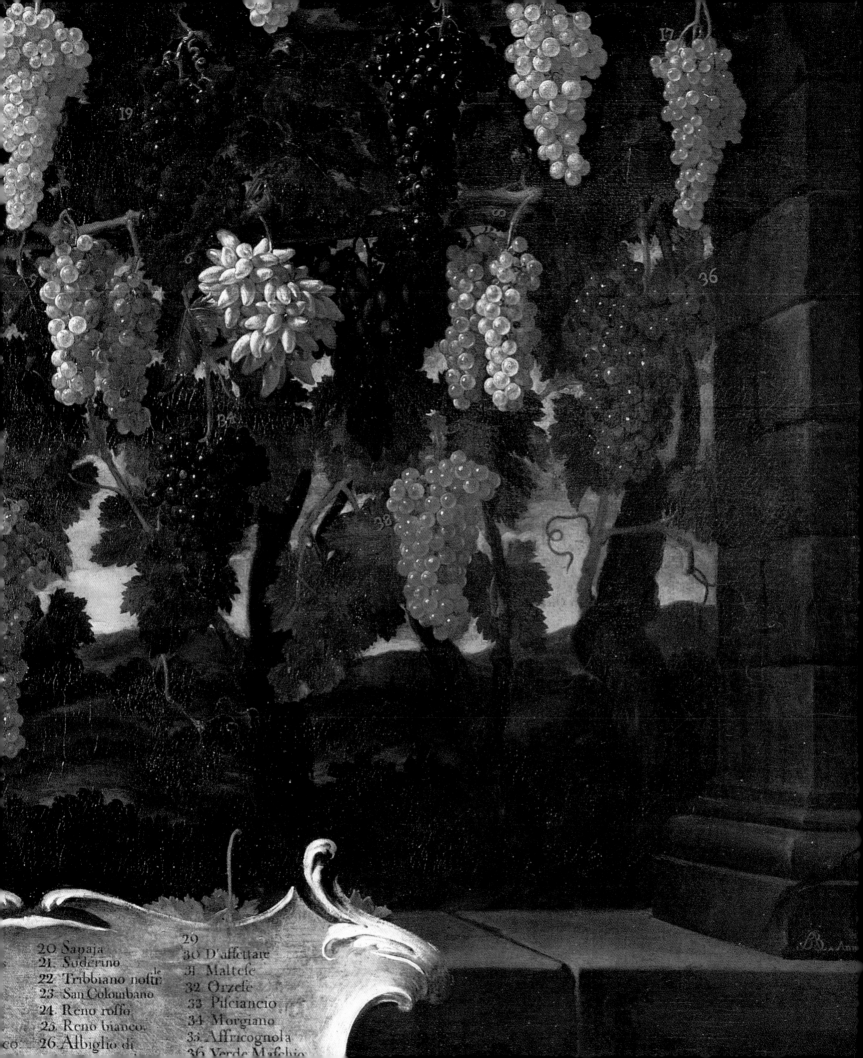

Bunches of grapes
have always been a source
of great inspiration over the centuries,
above all because they are linked
to the symbols of Abundance
and Fertility

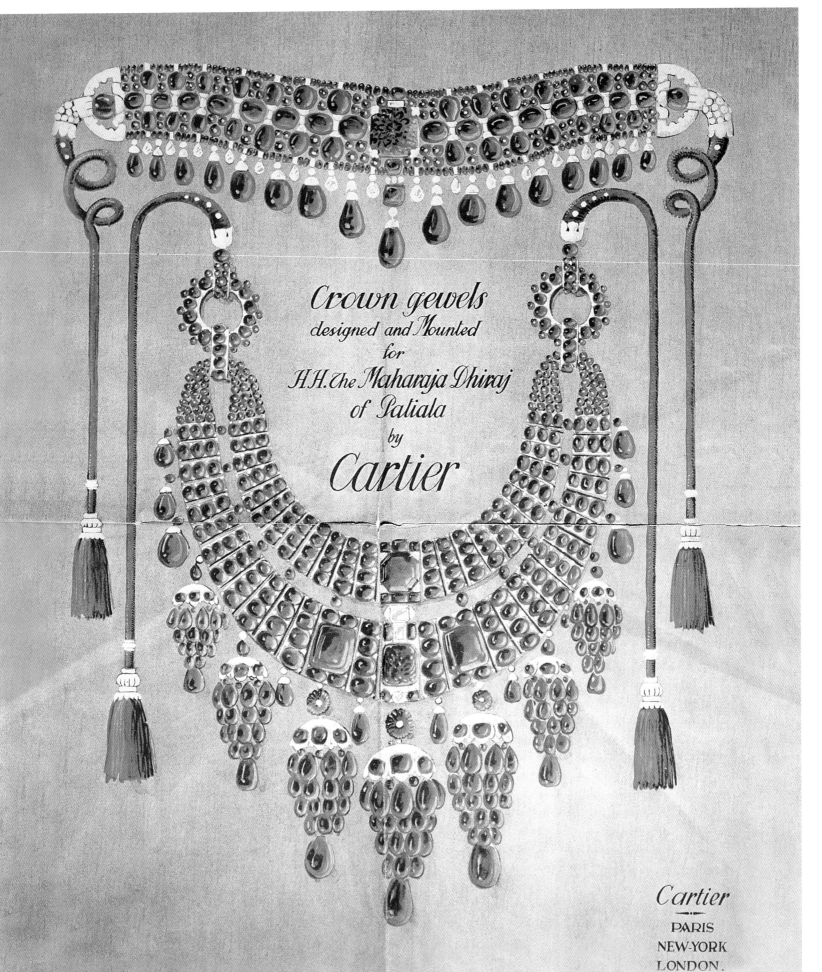

Crown gewels
designed and Mounted
for
H.H. The Maharaja Dhiraj
of Patiala
by
Cartier

Cartier
PARIS
NEW-YORK
LONDON.

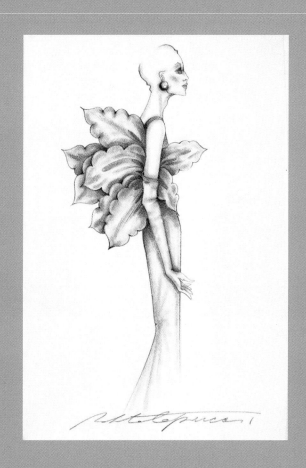

LEAVES
velvet and wild plum
Private collection. Autograph drawing by Roberto Capucci
Autumn-Winter 1982–83

The vine and fabric

The exhausted and voluptuous decadent colours
— enhanced with gold and black —
are inspired by the faded shades of dying nature,
such as pearl, ochre, petroleum, burgundy,
violet, peacock, rose and cream.

MARIANO FORTUNY, MANTEAU, 1910–14
MMT, coll. UFAC Inv. 86-42-I

with creativity and expertise

pp. 44–45
PALAZZO PITTI, SALA BIANCA, JULY 1959
G.B. Giorgini Archive

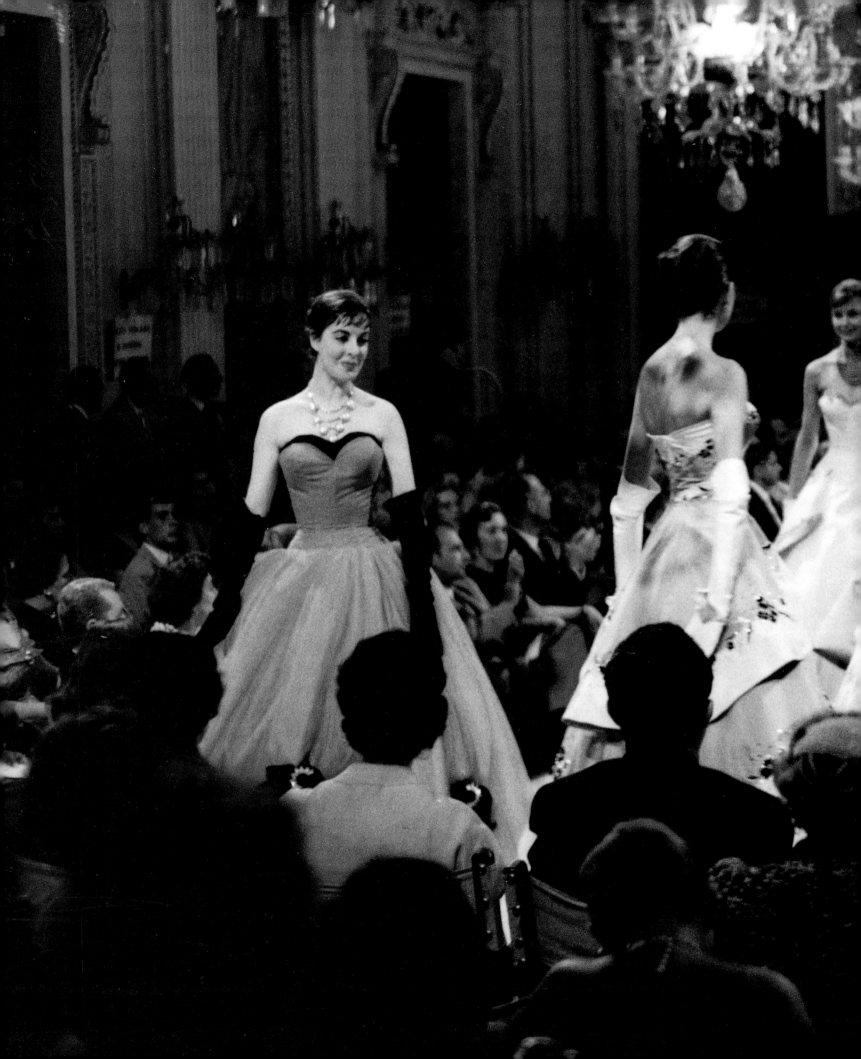

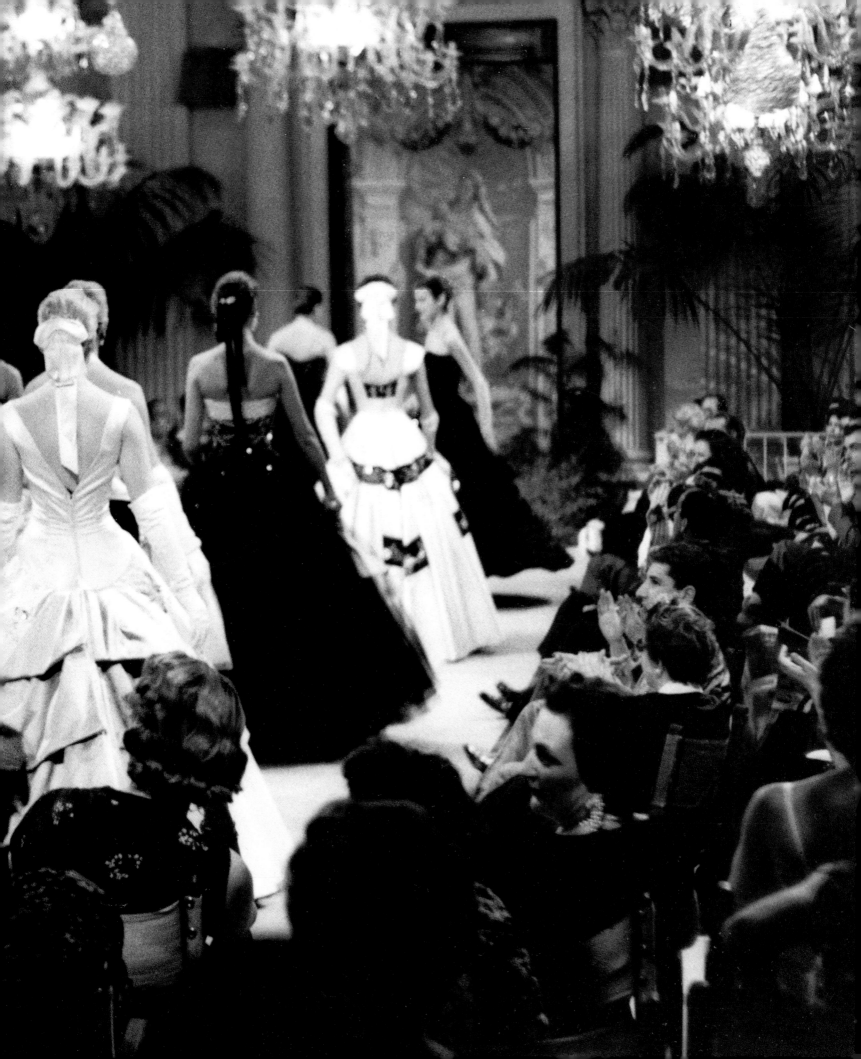

How is Wine created . . . and . . .

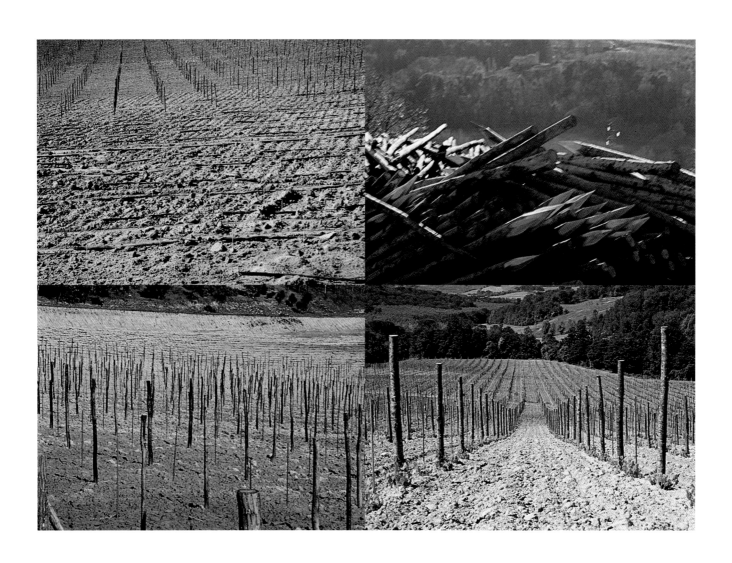

PLANTATIONS OF CORBAIA

Fashion? The same . . .

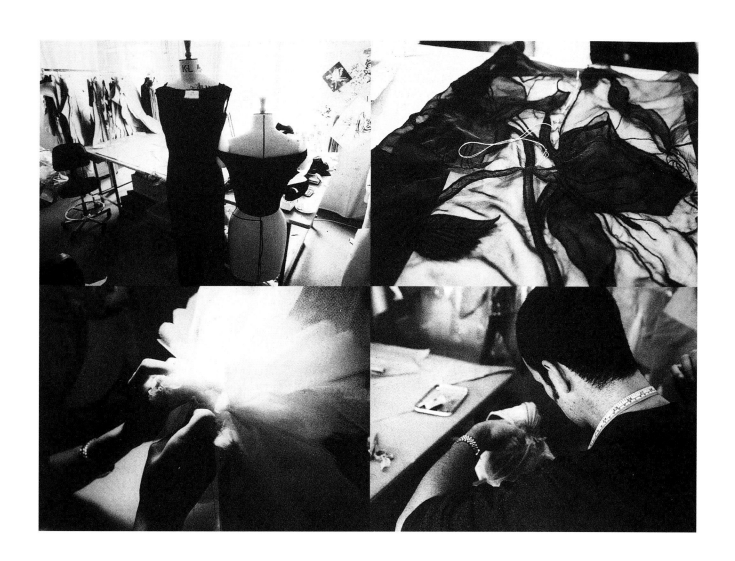

ATELIER OF JOHN GALLIANO

Passion . . . The same . . .

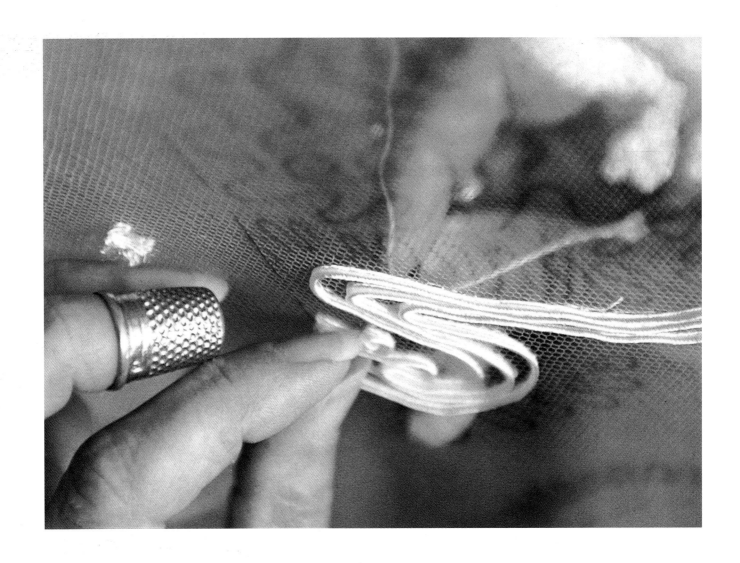

Perfection . . . in every detail . . .

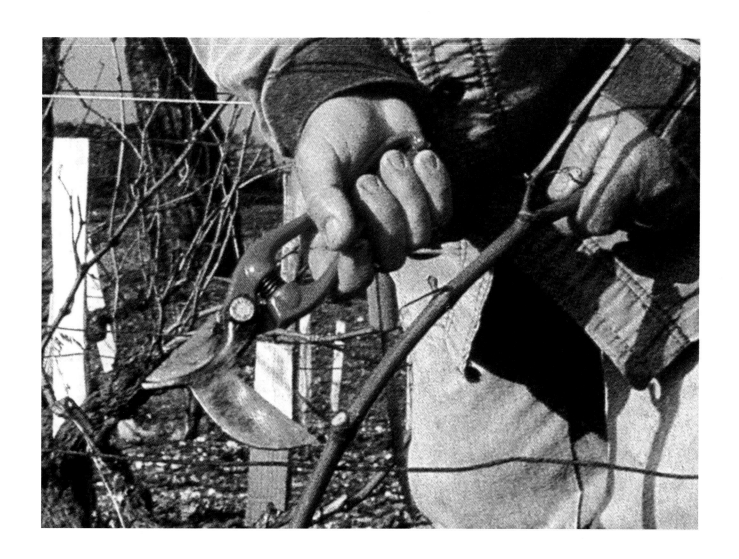

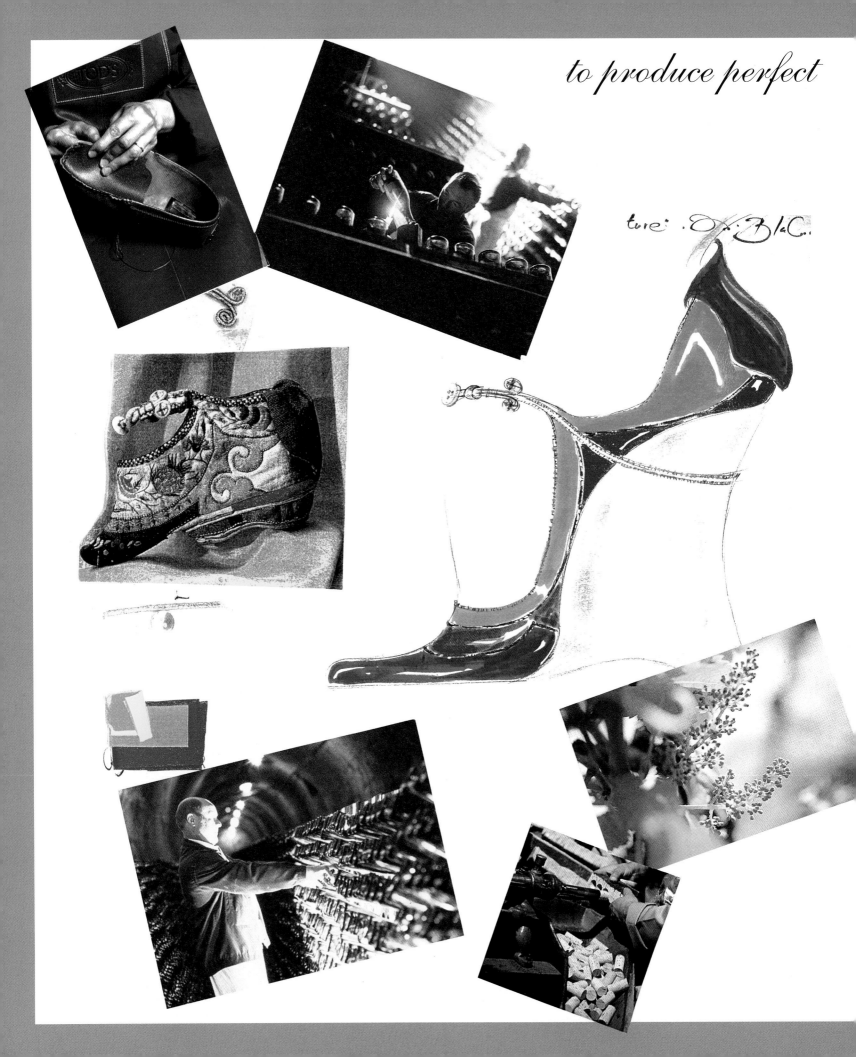

to produce perfect

Never stop,
never be satisfied with the results you've achieved.
And, above all, never forget who has contributed,
day after day, to our success!

Harmony...

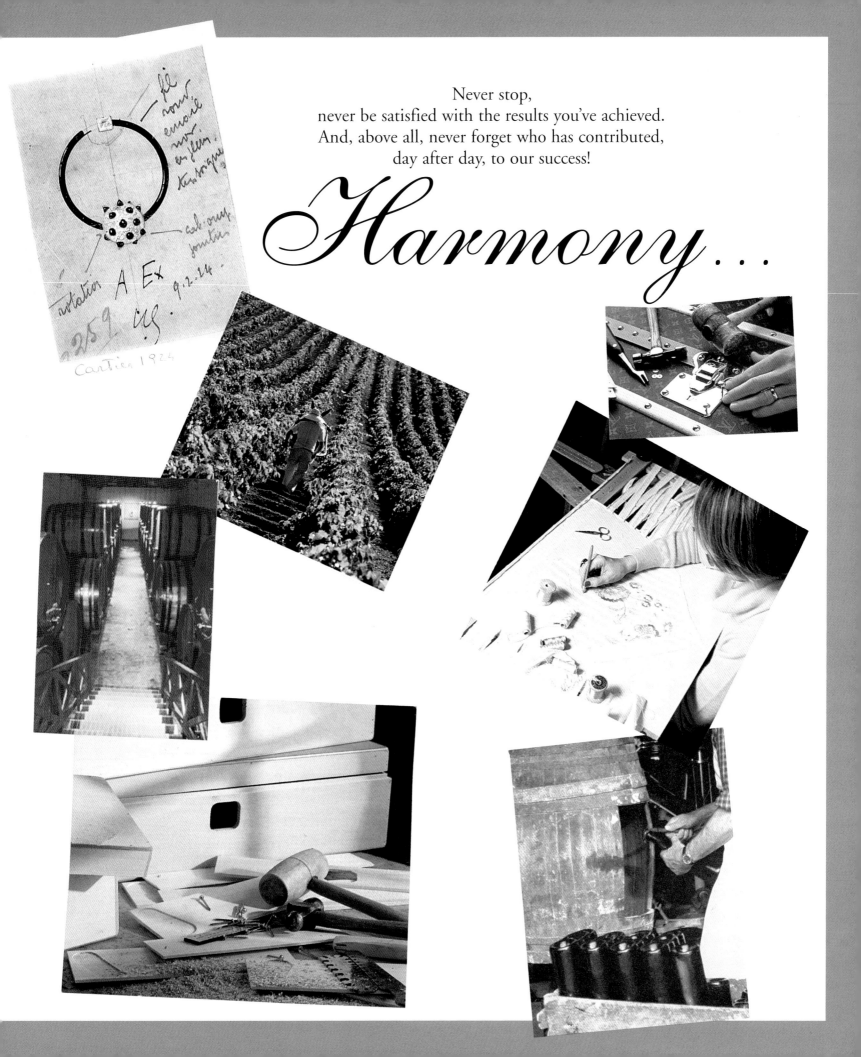

Sense what is Exceptional . . .

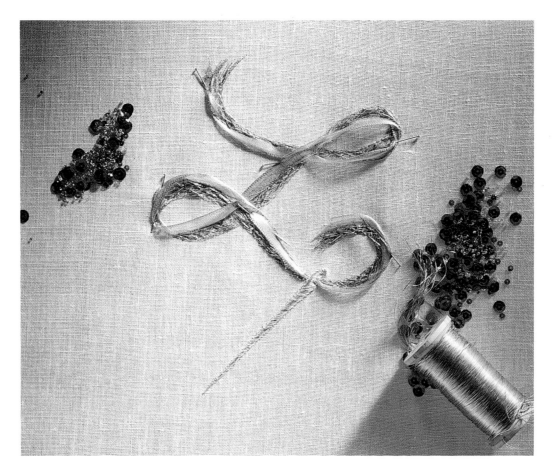

La qualité, une exigence globale

still draw on Treasure stores of Patience!

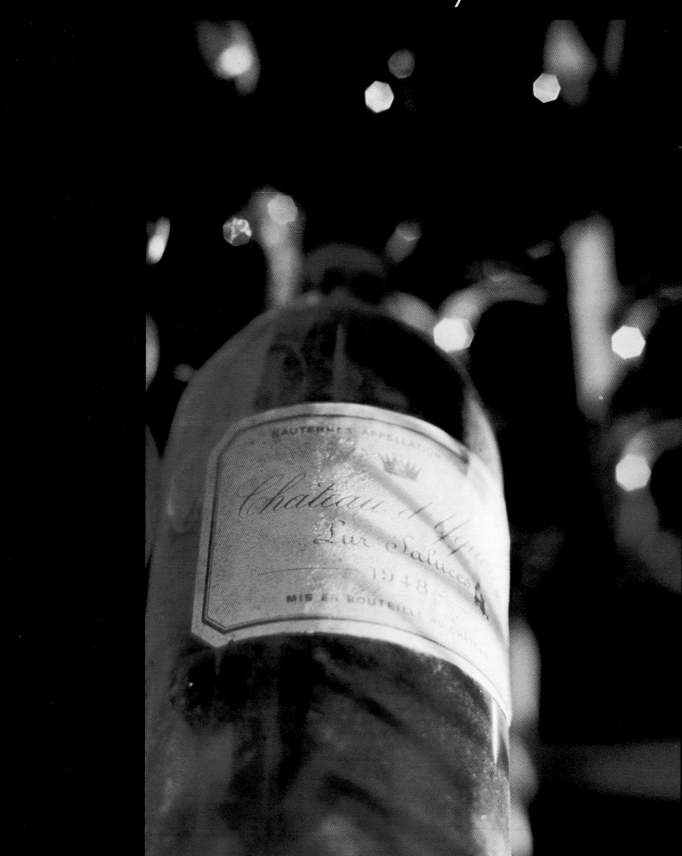

RENÉ GRUAU

Flair
Intuition

How many people are involved in the creation of a dress?

Is creation an individual affair?
Creativity that only flows at moments
when one is alone with oneself?
and…

How many people are involved in making a bottle of wine?

What is it that prompts the cultivation of Cabernet Sauvignon
instead of the usual Nebbiolo on the hills around Barbaresco?

Ideas are the fruit of an individual's inspiration
and bring life to the plans for a collection but,
in order for the collection to come into being,
these ideas must be worked on by many.

Collaborators are of great value, and sometimes indispensable,
to turn an idea into a finished product!

LES
DESSINS

57

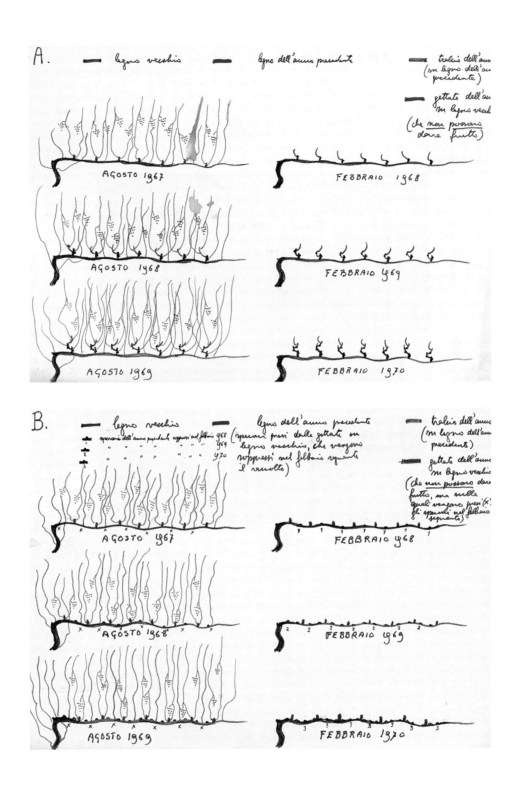

Mario Incisa used to give "drawn" instructions to his vine-dressers.
These, addressed to the land agent Giuliano Gabellini, tended to result in the avoidance
of the progressive lignification of the shoots of the vine and to raise the leafage from the soil.
Drawing A: left, the vines in the growing season; right, the traditional winter pruning.
In this manner, in just three years there will be a damaging overproduction of old wood on the shoots.
Drawing B: the pruning technique according to the marquis Incisa takes advantage of the shoots on the trunk
originating from latent buds. Pruned to a bud, they become "the fruit strands" the following year.
The old shoots are eliminated, thus avoiding lignification.

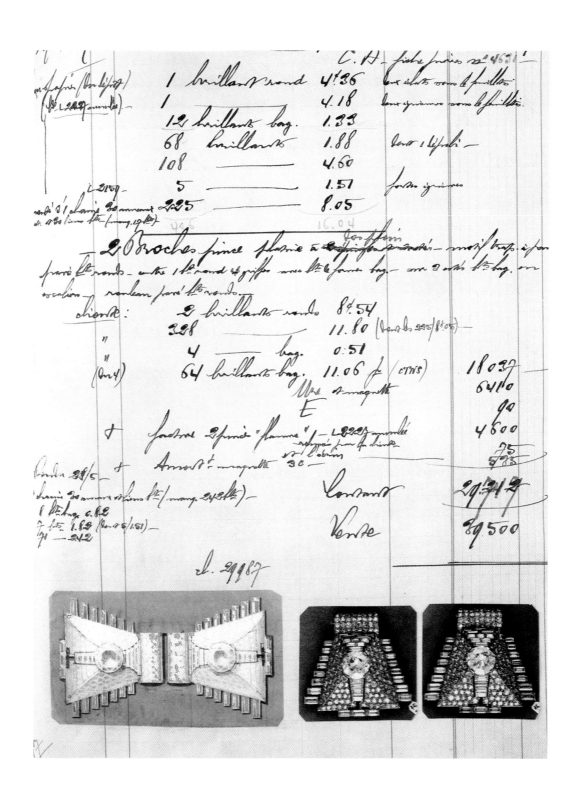

Cartier, original gouache pattern on beige paper for item no. 220
and the existing part of a pair of brooches that form a single article.
Paris, Cartier Archives

"Plans must be combined with action"

TASCA D'ALMERITA

BUILDING IN THE COUNTRYSIDE, IN A RURAL ENVIRONMENT, IS DIFFICULT ENOUGH:

WHEN THE PROJECT IS TO CONSTRUCT AN industrial building like a new vinery in the area of Chianti Classico between Florence and Siena, the task takes on monumental proportions. Like the interpretation of the "genius loci", the spirit of the place and of the bare, minimal agricultural environment in which every element — whether natural or man-made — is rooted in the soil, the seasons and the passing of the sun across the sky. In addition to this there is another strong element characteristic of the area: the human scale of the buildings and the way they are moulded into the shape of the land. Materials, colours, temperatures, smells and proportions are all sensory ingredients of the project which, combined with the physical characteristics of the construction, determine the charisma of a building in the same way as that of a fashion product.

NATHALIE GRENON

Badia Coltibuono. How should grapes, to be used in the production of vinsanto, be hung to mature?
With chains suspended from the ceiling and horizontal rods hung on rings I succeeded in creating a highly flexible system
that allows the suspension area to be altered depending on the size of the bunches.

La création du défilé

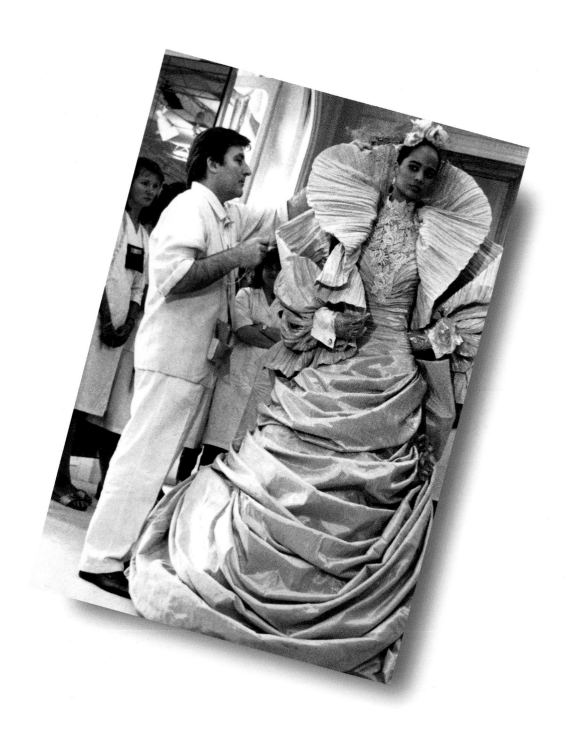

"Tout est mis au point.

Dans une collection, rien n'est laissé au hasard

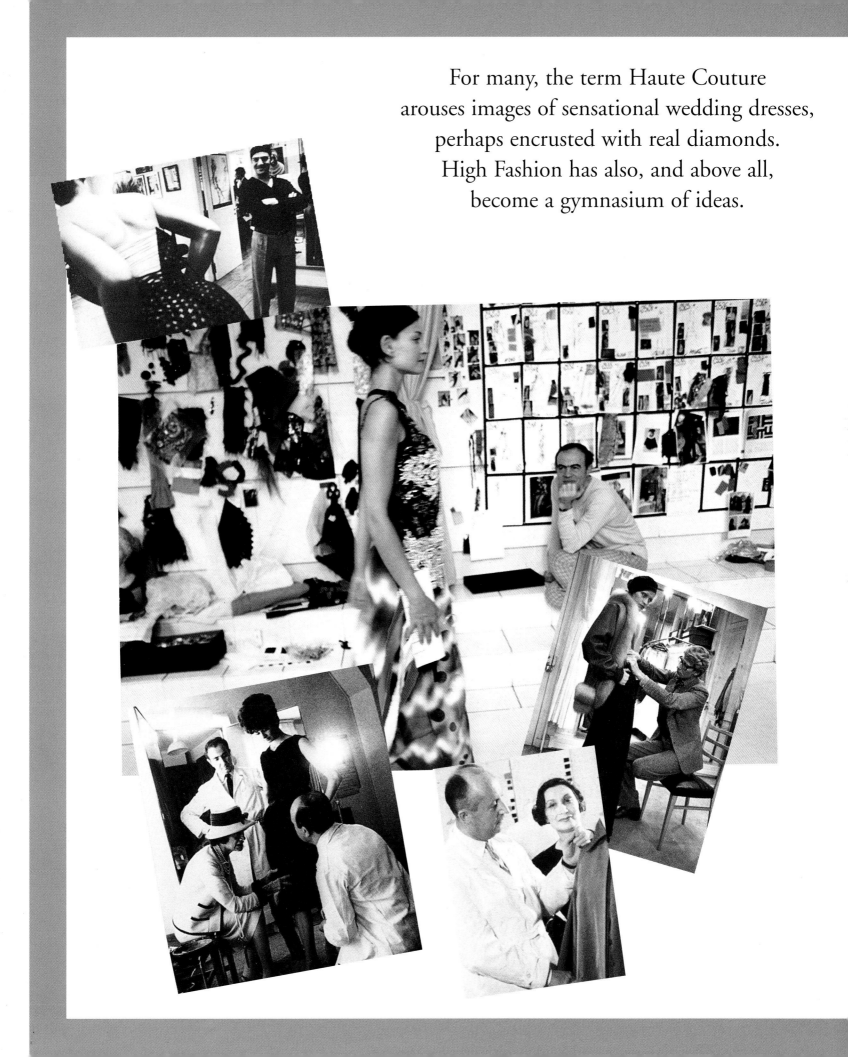

For many, the term Haute Couture
arouses images of sensational wedding dresses,
perhaps encrusted with real diamonds.
High Fashion has also, and above all,
become a gymnasium of ideas.

Flavour and Fashion of the New Millennium

JOHN GALLIANO

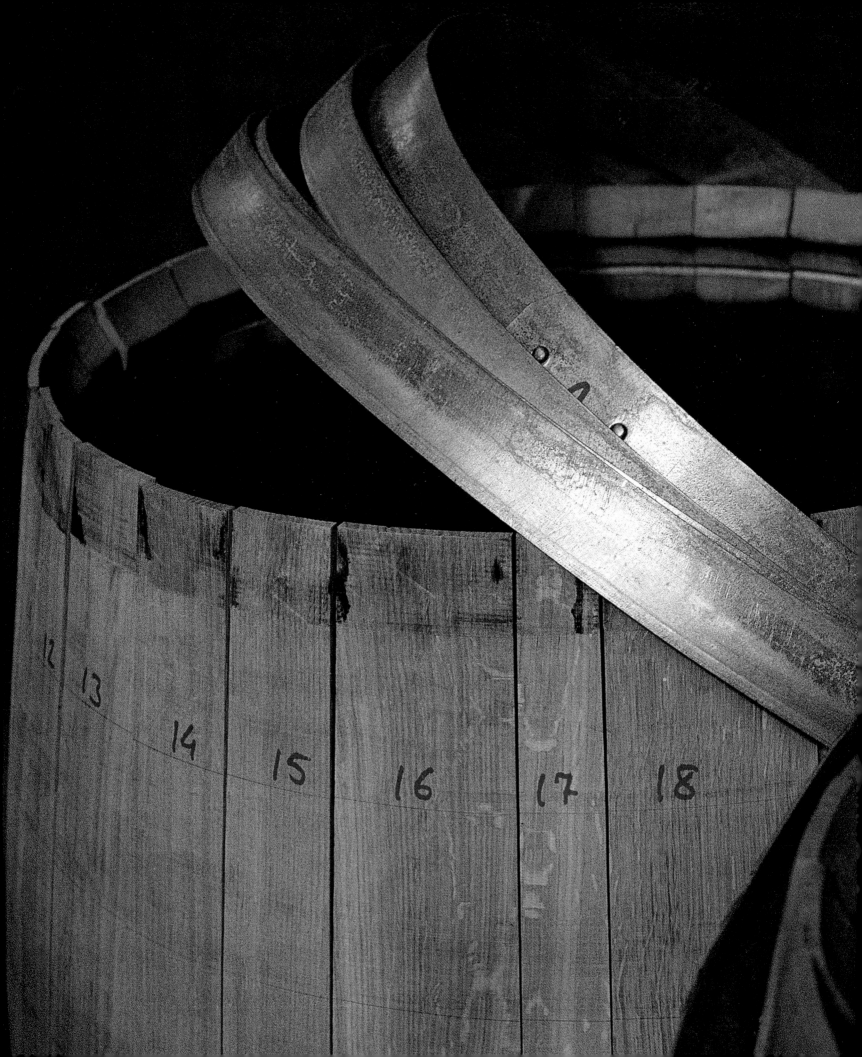

*"Ce qui donne
de la beauté
à une idée,
c'est l'énergie"*

"SI J'AVAIS DÛ MA FORTUNE À LA FAVEUR DU ROI, JE ME SERAIS DÉFIÉ D'ÊTRE COURTISAN; J'AI SONGÉ

à la faire en faisant valoir mes terres et à tenir toute ma fortune immédiatement de la main de Dieu."

Montesquieu disait aussi de son vignoble "... qu'il lui semble que son argent est sous ses pieds."

THE FRIVOLOUS COLOUR

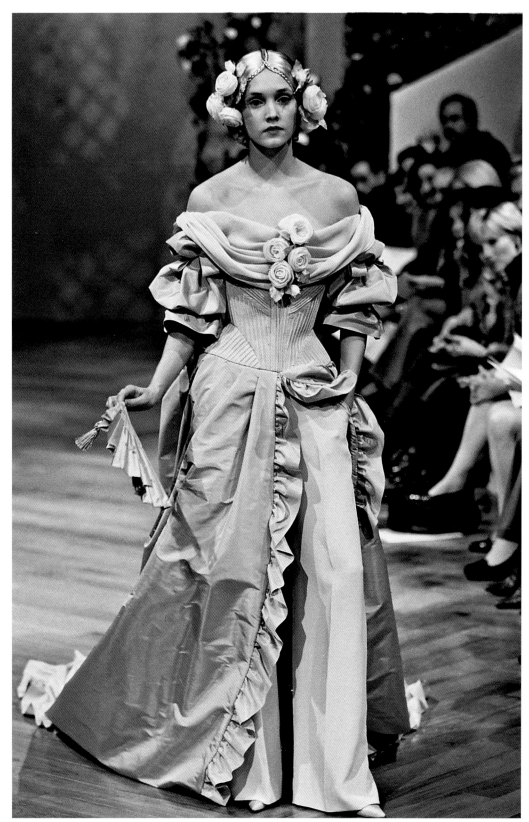

Hubert de Givenchy

In the eighteenth century, the taste for the artificial and fantastic
was woven around light, vaporous and sensual colours
that ranged from soft pastels, to warm and powdery shades, to rich, changing hues:
greys, sky blues, pistacchio, lilac, peach blossom and ivory.

THE COLOUR OF SENTIMENT

Colsandago, Wildbacher

The Romantic movement considered chromatic perception
as a natural internal experience and returned to colour the notion
that it is a non-quantifiable quality of pure emotional potential,
and of sensation that comprises all fields of experience.

Inspiration:
Thèmes et variations

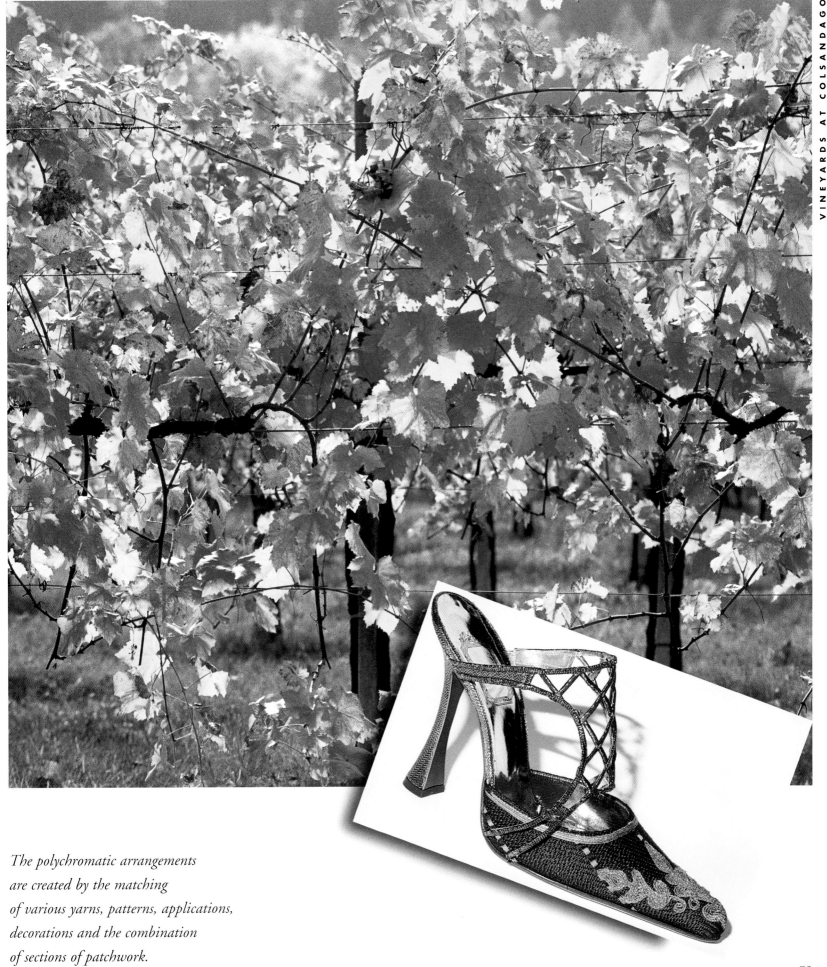

*The polychromatic arrangements
are created by the matching
of various yarns, patterns, applications,
decorations and the combination
of sections of patchwork.*

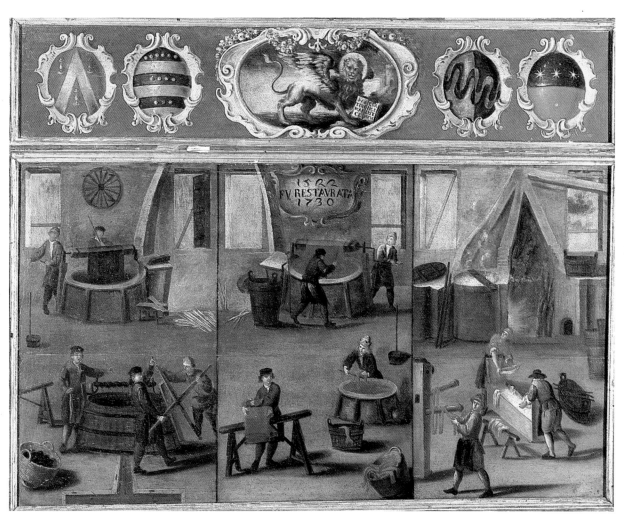

Colours, in which every century and nation takes delight,
are indicative of each nation's customs.

TOMMASO CAMPANELLA
Sopra i colori delle vesti, 1622

"Un peu de folie dans l'invention"

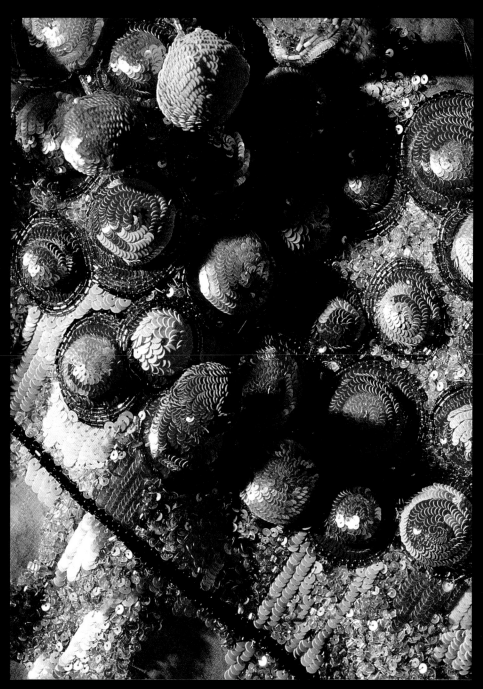

Detail of a bunch of grapes embroidered with beads and tiny sequins in the style of the painter Pierre Bonnard.
For Saint Laurent's 1998 Winter collection, Lesage used 45 needleworkers for 3 weeks,
who produced 18 dresses embroidered with patterns on the theme of grapes.

When speaking about Fashion…

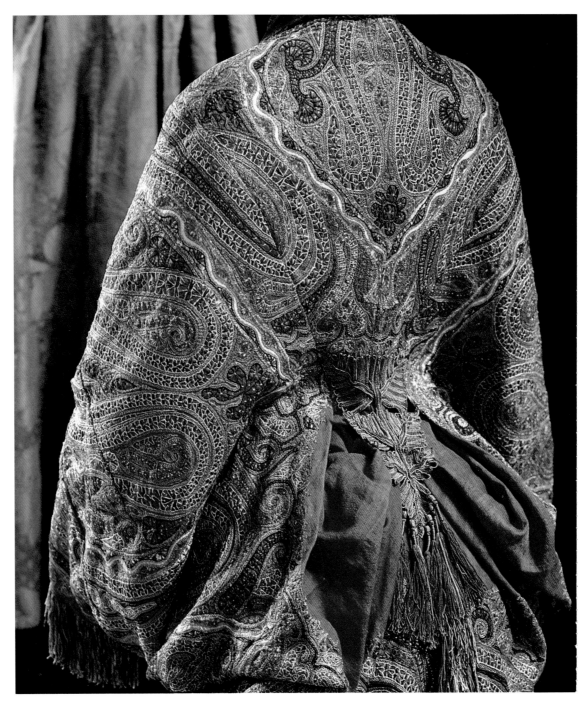

EASTERN FABRIC MADE FROM CASHMERE, 1850

we are also speaking of Wine…
closer to Bordeaux… as long as it is not Must…

MATERIAL PLEASURES

THE COLOURS
OF DRESSING
IN HIS POEM VOWELS,

RIMBAUD EVOKED PICTURES AND COLOURS

THROUGH SOUNDS, USING COLOURED

SYNAESTHESIA TO DERAIL HIS SENSES:

A black, E white, I red, U green, O blue: vowels,
I shall tell, one day, of your mysterious origins:
A, black velvety jacket of brilliant flies
which buzz around cruel smells,
Gulfs of shadow; E, whiteness of vapours and of tents,
lances of proud glaciers, white kings, shivers of cow-parsley;
I, purples, spat blood, smile of beautiful lips
in anger or in the raptures of penitence;

U, waves, divine shudderings of viridian seas,
the peace of pastures dotted with animals, the peace of the furrows
which alchemy prints on broad studious foreheads;
O, sublime Trumpet full of strange piercing sounds,
silences crossed by Worlds and by Angels:
O the Omega! the violet ray of His Eyes!

EMILIO PUCCI

In 1969 Emilio Pucci produced a series of rugs in twelve different designs and five colour variants for Dandolo y Primi in Buenos Aires.
The following year, these rugs made from local wool were displayed in the Museo Nacional de Arte Decorativo in Buenos Aires.

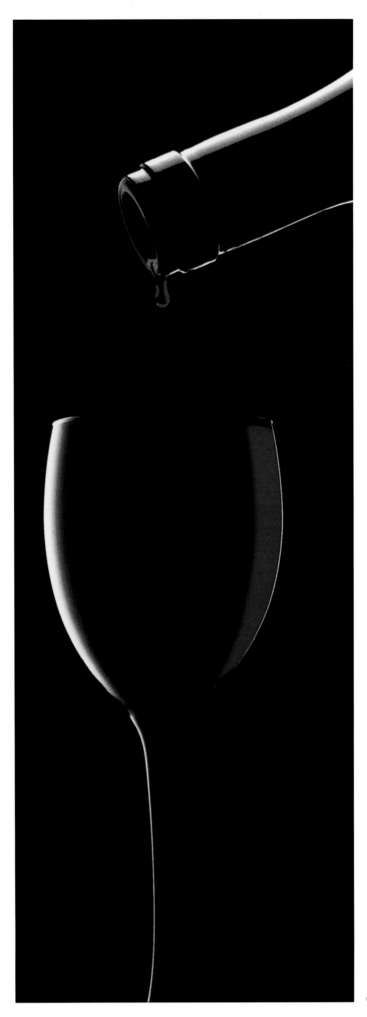

84

"DRINKING A GLASS OF RED WINE. STROKING THE SLEEVE OF A JACKET THAT TIME HAS MADE MORE PRECIOUS. CHOOSING A PULLOVER FOR ITS BRIGHT COLOUR. THEY ARE ALL SENSUAL FEELINGS BECAUSE OUR SENSES ARE OUR FIRST MEANS OF MEDIATING WITH THE WORLD."

Wine for me represents tradition. Colour, smell and taste take me back to domestic landscapes, to the nobility of the past. Wine is also a eulogy to slowness: growth requires the tranquillity of meditation. On the other hand, through touch and sight, clothing speaks to me of the present and the future. The weave of the fabrics today mix tradition and high technology. Colours speak to me about life. Because everything has its colour, even vowels in the opinion of Rimbaud (A black, E white, I red, U green, O blue). To Kandinsky, each colour corresponds to the sound of an instrument. Yellow, for example, is the blast of a trumpet, a movement forwards, a sudden release of energy. Colours are never still: what will be the chromatic note of tomorrow?

LUCIANO BENETTON

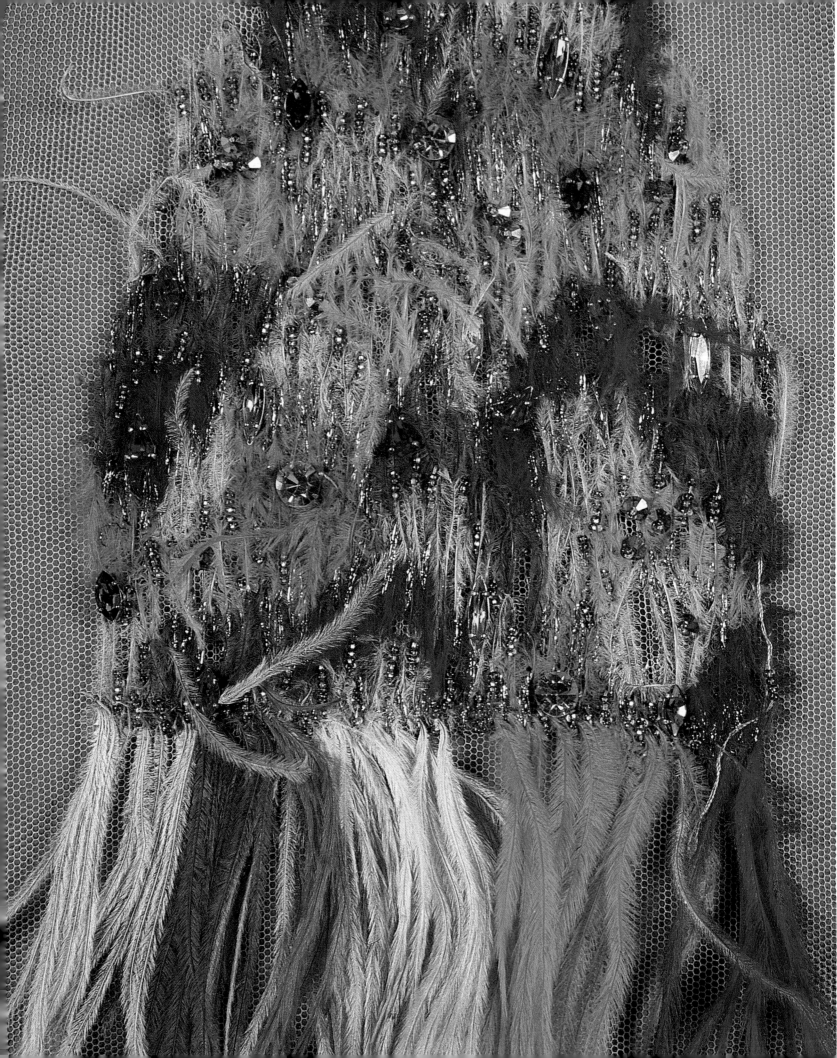

Lesage, detail of a corset made from sequins, coloured pearls and coloured ostrich feathers

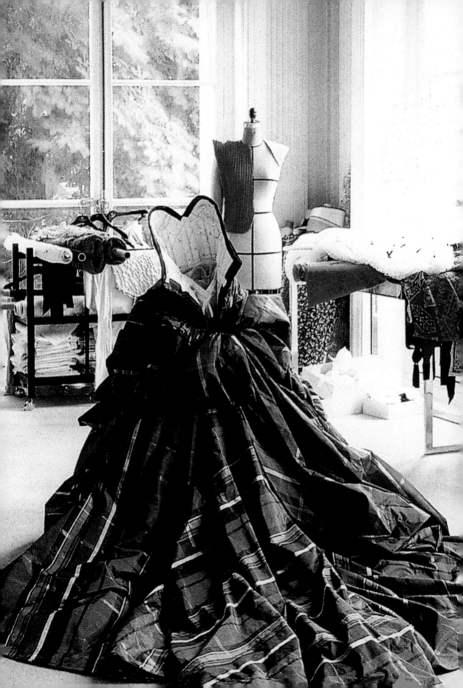

Satiating oneself with Images

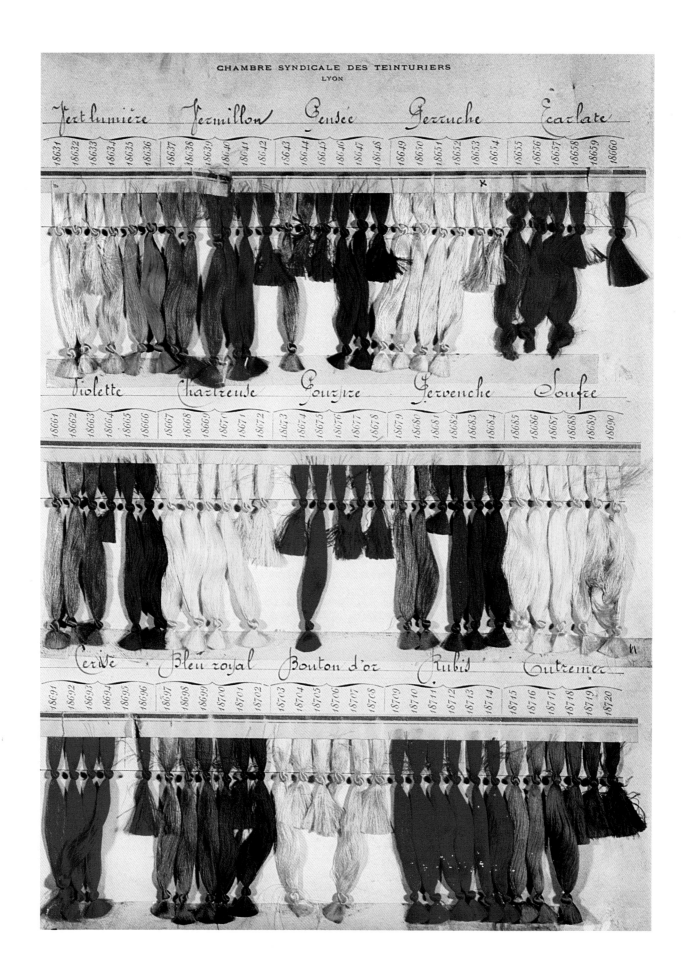

RED

Causes agitation and encourages action.
Indicates a sense of strength and security.
Corresponds to self-confidence and trust in one's own strengths and abilities.

BLUE

Induces peacefulness and denotes a state of satisfied adaptation.

GREEN

Corresponds to feelings of solidity, stability, strength,
constancy and behaviour typified by perseverance.
The choice of green signifies self-esteem.

YELLOW

Relates to the brilliance that arouses and gives colour.
Corresponds to a condition of freedom and self-development.
Those who prefer yellow tend to look for change and the new.

VIOLET

The colour of metamorphosis, transition, mystery and magic.
A favourite of children, pregnant women and immature personalities.

BROWN

Corresponds to materialness or physicalness.
Those who like this colour are enthusiasts of what is corporeal and material,
and therefore like physical pleasures.

GREY

This is the colour of perfect neutrality.
Chosen by those who prefer to keep their distance and not become involved.

BLACK

Represents absolute negation, a radical "no".
It is the colour of opposition behind which a claim to power may lie.

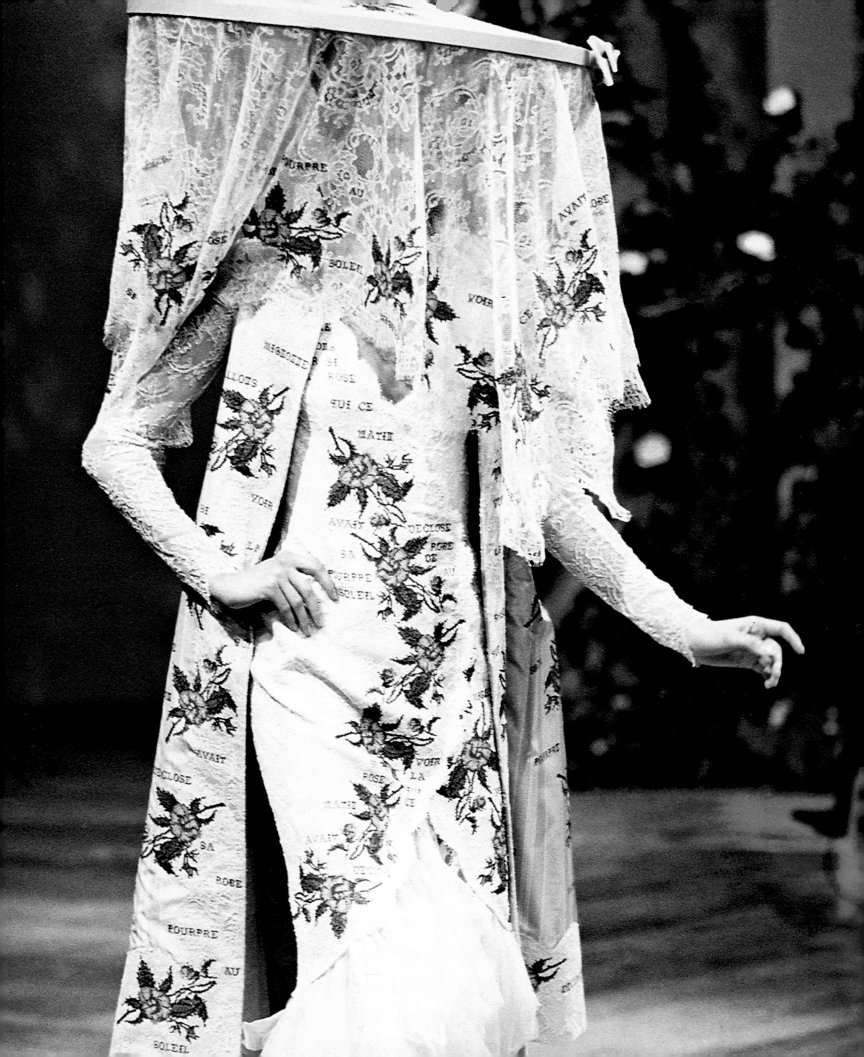

Rose
Scents & Sensibility

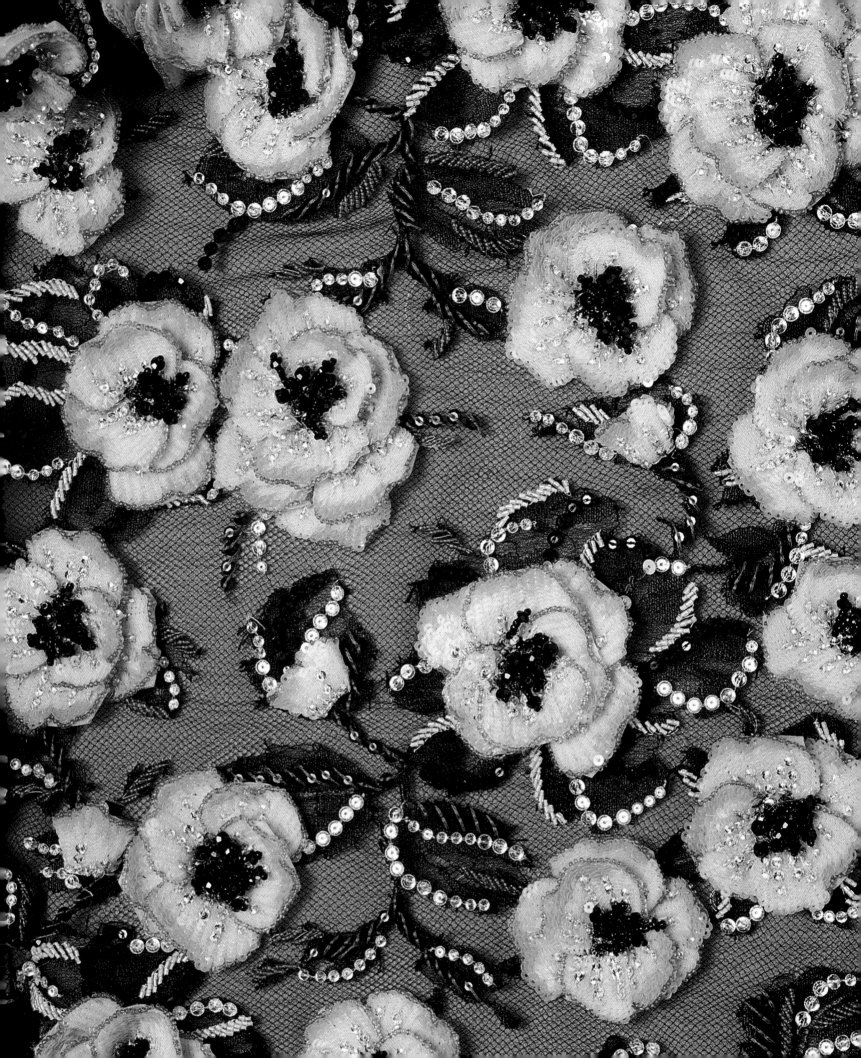

THE VIRTUES OF A ROSE.

THE GREAT COMPANION
OF THE VINE IS THE ROSE,
WHICH IS A PERFECT EXPRESSION

of the protective values of a vineyard. Through its "sufferings", it displays powdery

mildew, but it also improves transformation of the vine's ovaries into fruit.

NOT ONLY WHITE
OR RED, BUT ALSO PINK.
THERE ARE STILL PEOPLE WHO
WONDER WHAT IT IS THAT HAS MADE WOMEN

successful in the world of wine, which, for so long, has been the territory of men. Perhaps because there have always been women in wine and their contribution, especially in the vineyards, has always been essential. And if a great number of seductive meanings have been attributed to Eve's apple, how many, and how poetic, have been given to grapes and wine by those who have voluntarily experienced the art of seduction. Women know from fashion how to exploit elements that compliment them, but if these elements do not permeate their personality, the result is not convincing. Women in the world of wine can count on the seductive qualities of their movements, their words and their style of dressing, but success will only come to them — and their wine — if there is a physical interpenetration of all these elements. A woman can seduce a partner with the inebriating bouquet of a wine, with the pleasure given by a sparkling wine, or the power of a great red. The combination of fashion and seduction, in the hands or, better, in the mind of a female lover, the mother of her wine, becomes a persuasive, warm and conspiratorial force. An encounter between men is equally balanced. But in an encounter between a woman and a man, the balance inevitably shifts — in favour of the woman. Between the seductress and the seduced, the game is always open, even in the world of wine. Otherwise, what pleasure would there be in fashion and wine if there were no hint of bewitching imagination? Women in wine today receive a good press thanks to the rose: doesn't all this suggest anything to you?

RENÉ CAOVILLA, GIORGIO GRATI

... *He wound bunches of grapes*
into his hair and the liquid
of the crushed grapes dripped onto his lips.
Bacchus sucked the sweet liquid happily.
Seated on the ground,
he took a cup and gently squeezed
the mature grapes into it,
then the juice was transformed
into wine by his divine will.
Bacchus laughed,
mixed the heavenly drink with a horn
and drank... his eyes lit up with joy.
And, from that day,
man had had the heavenly drink as a gift!

ARIANNA'S THREAD, 1962

LEILA MENICHARI FOR HERMES
Falaise en cristal de Synthèse

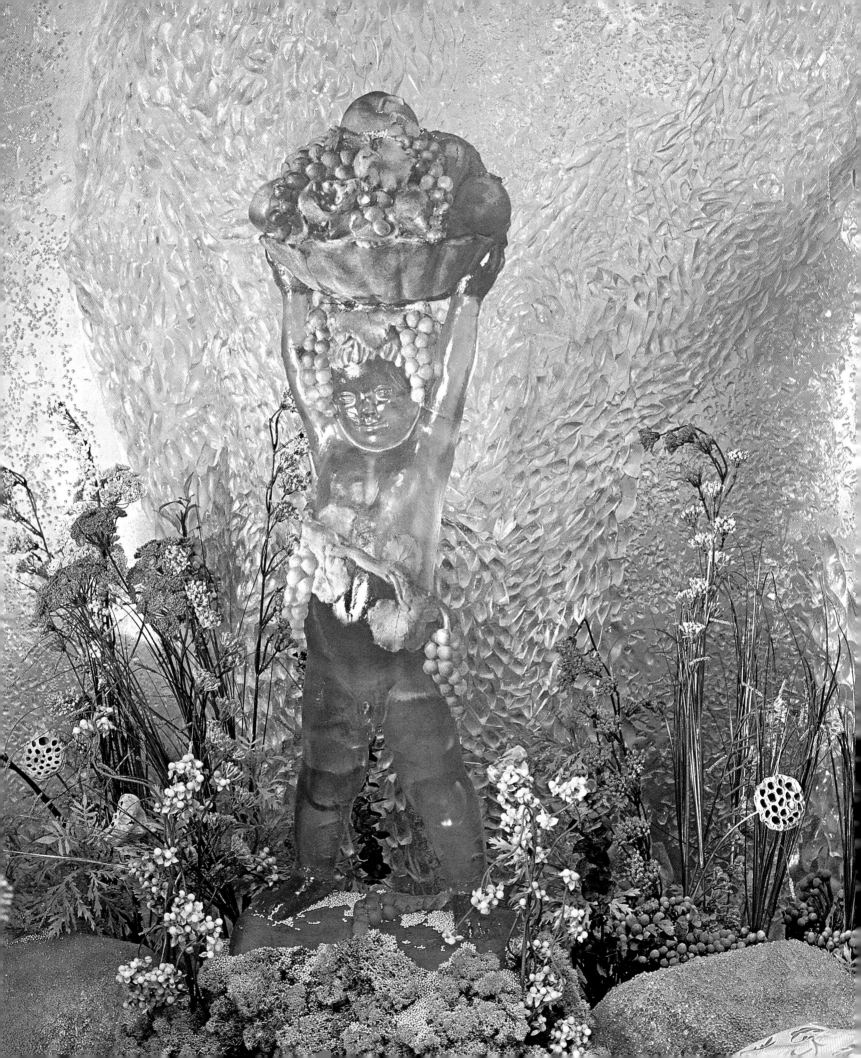

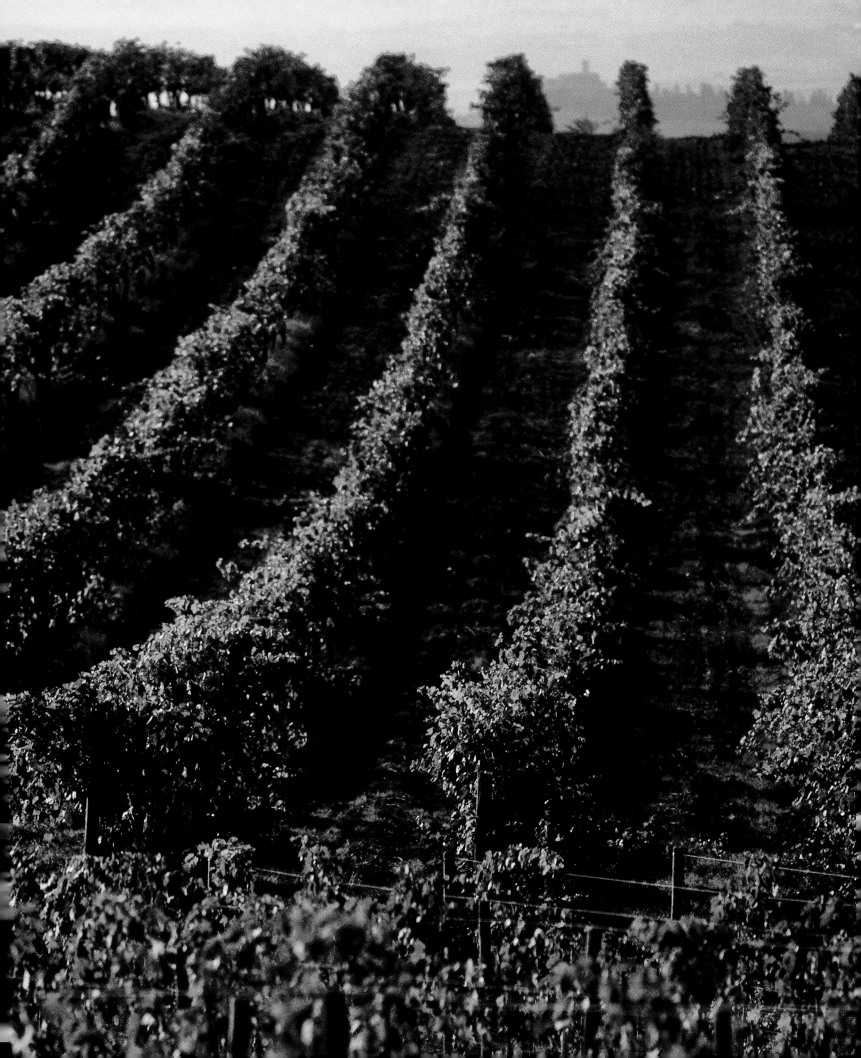

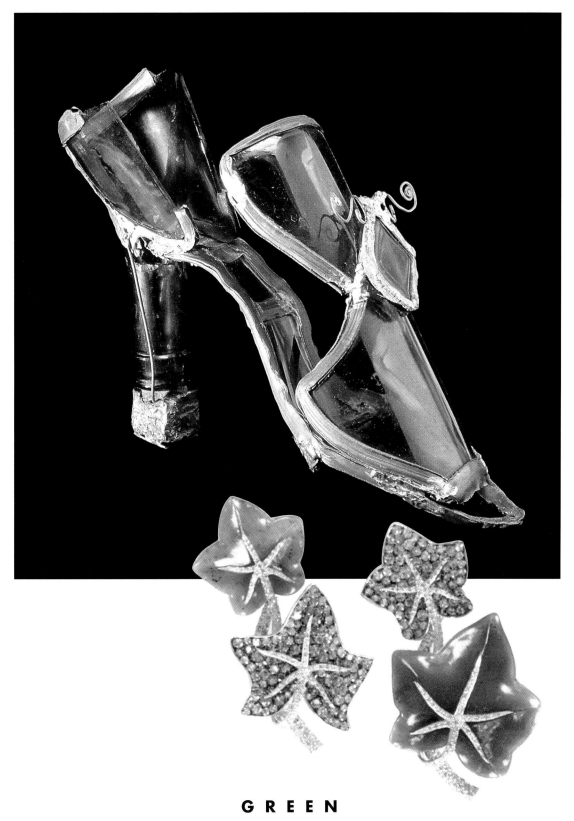

GREEN

the colour of Venus and the emerald, represented the virtues of hope,
courtesy, frankness, beauty, friendship, health and peace.

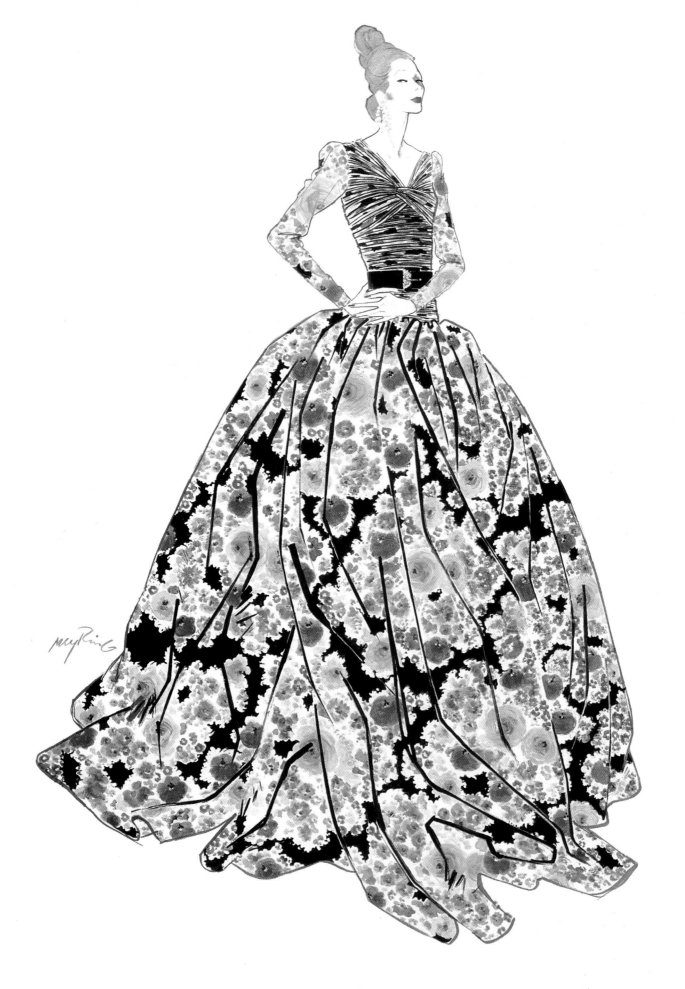

VALENTINO

Printed flower dress with draped bodice. Pattern by Michael Meyring

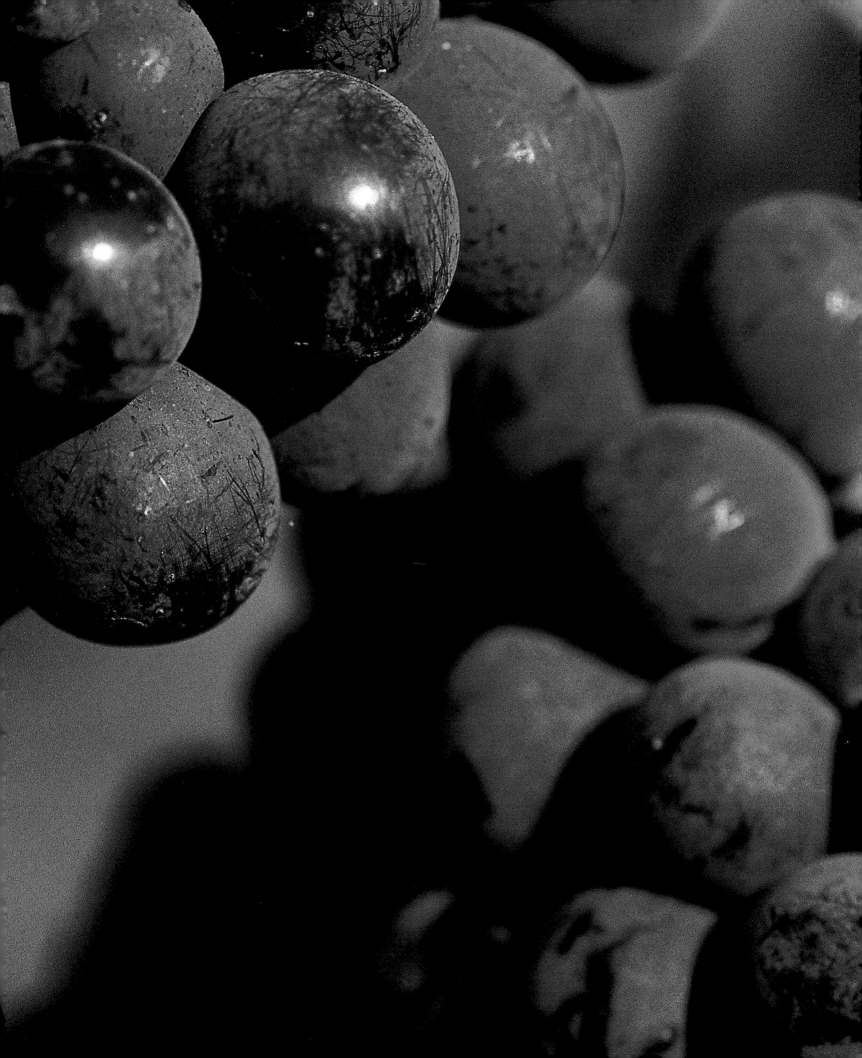

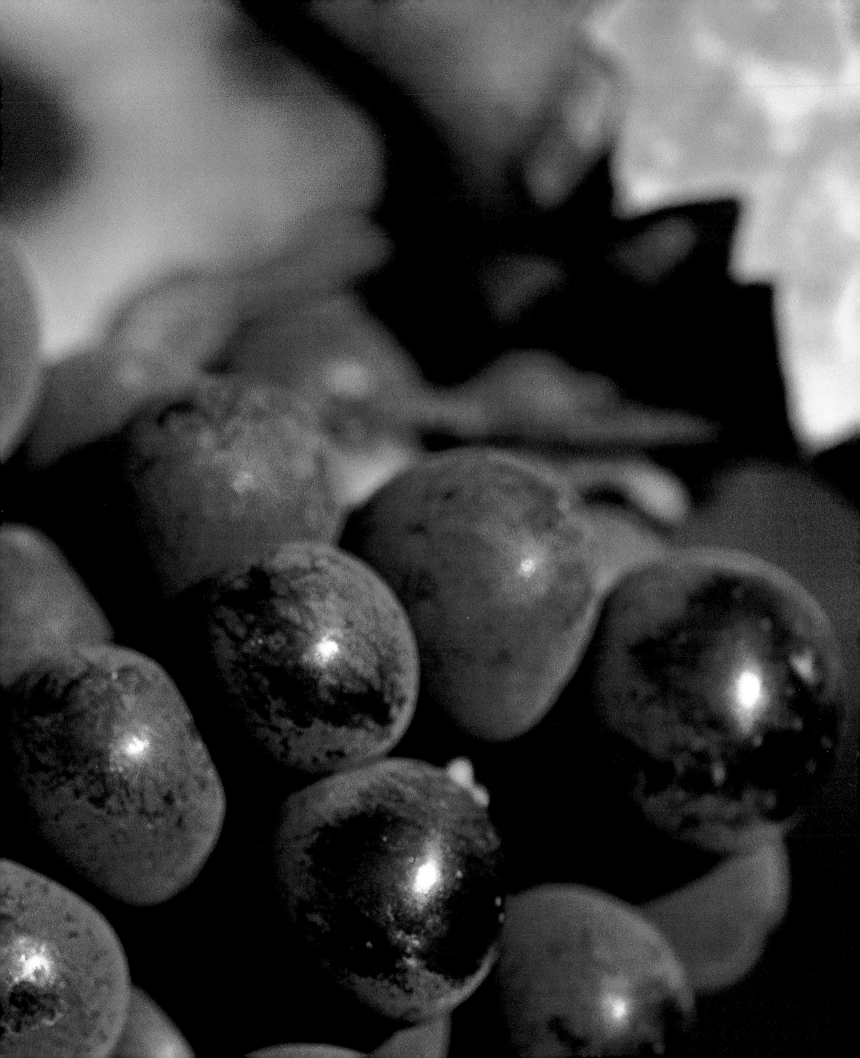

SAUTERNES
first year fermentation bung

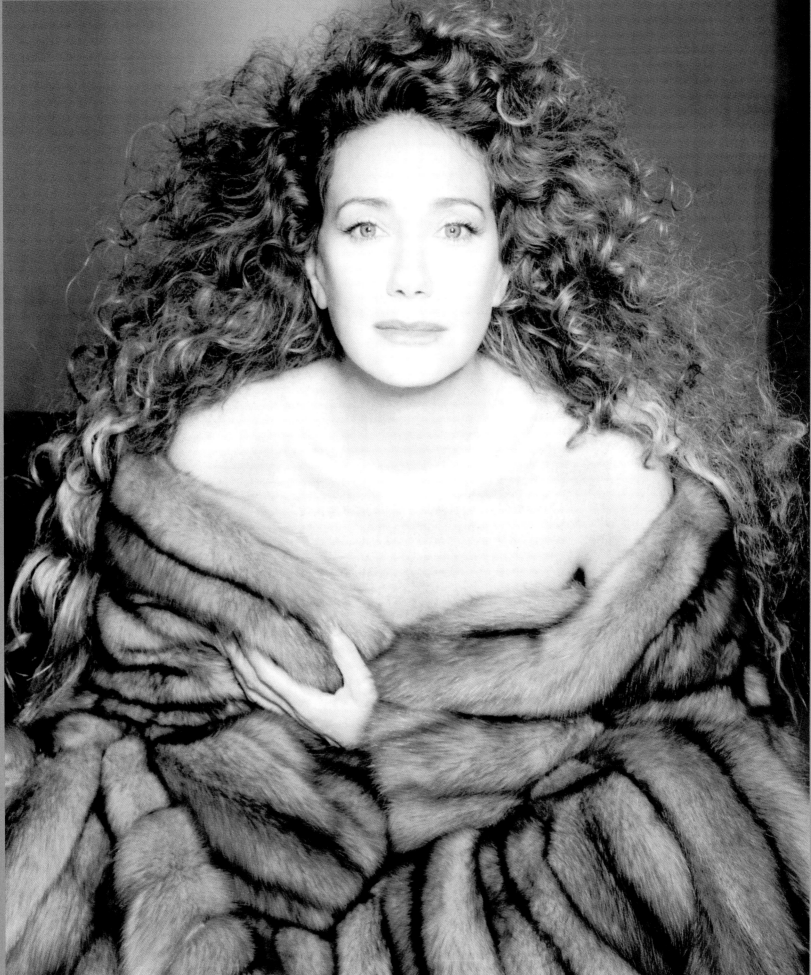

SEDUCTION, A MALE PREROGATIVE.

WHO? CIRCE, CLEOPATRA, THE COUNTESS OF CASTIGLIONE, "LA BELLA" CAROLINA OTERO, MATA HARI OR GRETA GARBO:

all of them great seductresses, procurers of love and languor, jealousies, torments, pleasure and damnation. Women. It has always been thought

that the attraction, the dart of love has been shot on the sly by the female, the female of easy virtue, temptresses like Eve or inspirations like

the ineffable Beatrice for Dante and Laura for Petrarch. In the anthology of love, men only seem to be the receivers of the message, painted in

literature as generous victims or, on the contrary, as masters, despots or tyrants in impeccable tuxedos or miners' overalls. Conquerors or se-

ducers? In the history of love, and encounters destined to lead to great passion, the males conquer by "predestination". Seduction seems main-

ly to be a female prerogative. Neither Julius Caesar nor Antony were seducers, both were seduced by Cleopatra. The gallants of the eighteenth

century were professional lovers and noted seducers who were hired to fill the part of absent husbands busy at work, or simply of secret lovers;

these "willing" and available men — the precursors of the modern gigolo — were hired by the busy husbands as official "escorts" to compen-

sate their consorts for the conjugal solitude into which they had fallen, or so the enlightened eighteenth century thought. Casanova was more

of a libertine than a seducer, attracted, as he was, by an ever changing variety of women and incapable of fixing his amatory proclivities on a

single individual. Fundamentally faithful to a role that cast him always next to a woman, he preferred the frontal attack, jumping straight to

the point without prevarication, without wasting time in courting or the lead-up to a relationship. Casanova's non-stop libertinism had noth-

ing to do with seduction as he fell in love on every occasion, and believed, or at least convinced himself, that his current partner was the "woman of his life". His impudence, his unscrupulous attack, his direct assault and tactics were deplorable, but, to some women it seems, they were greatly effective and highly pleasing. Casanova did not need circumlocutions, he let his hands, arms and whatever else do the work; he did not fear resistance, he knew he would win, and victory over the woman of the moment became a confirmation of a power that he never accomplished in personal relationships, either with men or in the world of work (where he did achieve such recognition). A successful man of letters, a good preacher, an able politician, a seasoned traveller, and a winning gambler, but he was never able to consider himself a man of power. It was better to fight in the field of women where success could be had by storming the bastions and by conquering, and with a prize at stake that could not be disputed. Among the great lovers of history, Lord Byron was more of a seducer, using poetry and sentimental verses during the Romantic era of the nineteenth century as powerful allies to gain his female conquests. Byron treated women as one element of a universe that existed to provide him with pleasure and entertainment. Beauty, tenderness and passion were elements that the English poet neglected, preferring seduction to arrive at his conquests' hearts. He aimed for the heart, he used to say, and the rest followed as a trifling consequence, to be enjoyed or not, and nothing to the pleasure that the seduction itself offered, requiring, as it did, time, letters, messages in verse, waits, the chase, and often flight to evade an offended husband. A true seducer, perhaps the greatest in history, was an invented man: Don Juan. His diabolical ability to ignite love, passion, devotion and abandonment, so that, lovelessly, he could drag them into love, licentiousness and a delirium of jealousy and uproar, gave him a negative power: control over all of them, and the subtle pleasure of deceiving and disappointing, of arousing feelings and affections that were immediately refuted. This was the goal of the true seducer who had mastered the "tactics" attributed by the literature of the past mainly to the kind of women referred to as femmes fatales, i.e. the heroines of royal alcoves, experts in the art of feigning

CASANOVA PORTRAYED BY THE PRICE OF LIGNE

"Wanna drink, baby?"

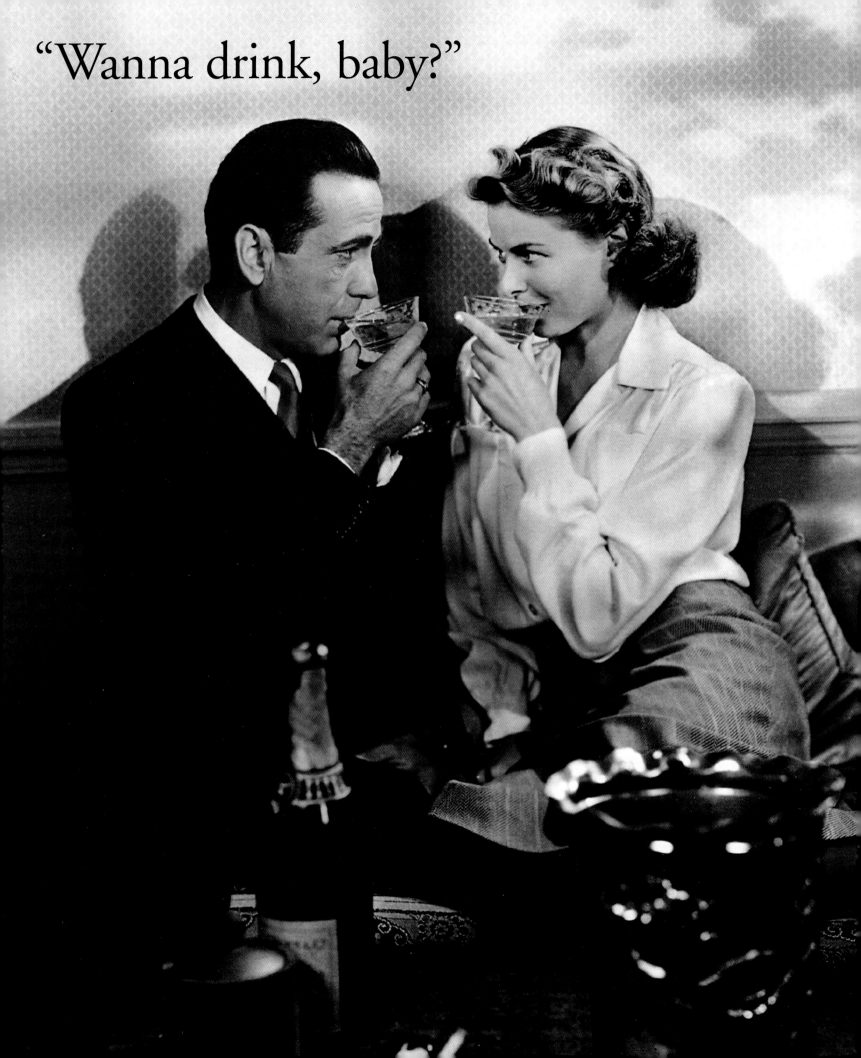

their submission so that they could seduce all the better, in the end conquering powerful men and, with them, "power". Another seducer, like Don Juan, who did it for the pleasure of enumerating his conquests, was the poet Gabriele d'Annunzio. For him, the art of seduction evolved until it became an almost feminine side of his personality; it touched on the heights of irreverency and religiousness, verged on the ridiculous, skimmed lightly over being ironical and was touched by cynicism. Like all seducers, the bard always fell in love (probably with love or with himself in love) but never actually loved. The weapons of seduction? Those that have always been used: clothing, ambiguous and devious behaviour, dishonesty and the use of symbolic objects. Seduction has always made use of coded language: fans, for example, were often used to pass messages of love. Originally only used by prostitutes (as a sign of identification of their profession), it was ennobled to the status of a female fashion accessory in the court of the Sun King but most of all as a means of communication. With the passage of time, the messages fans could transmit became more compromising: closed and resting on the cheekbone, a fan meant "Go away". Shaken excessively, they were an invitation to a daring suitor to moderate explicit behaviour. Closed suddenly, it meant "Enough! No more!". Placed open over the lips as if to hide the mouth, it said, "Kiss me!". Seduction: during the last decades of the twentieth century it seemed almost a forgotten term, erased by a culture increasingly based on speed, the need to achieve, to hurry. Conquer now. Know one another — in the biblical meaning of the word — immediately. From the hyperseductive Rudolf Valentino, the passionate hugging and clawing of pillars and curtains by Francesca Bertini and Lyda Borelli, to the satin chaises-longues on which languid divas reclined awaiting seduction, the cinema of the twentieth century landed on the grasslands of the West around the middle of the century. This was the period of the moustachoed Clark Gable, involved in the complicated and protracted girations of seduction in the westerns of the era. This was the moment when seduction — that was considered a female art in practice — crossed the Rubicon and became a wholly masculine practice. Who seduces in *Casablan-*

ca? The intense but cool eyes of Ingrid Bergman or the dark gaze and eternal trench-coat of Humphrey Bogart? Far from the fan messages of female seduction, for the men of the second half of the twentieth century the tool of seduction was the cigarette, permanently accompanied by a tinkling glass of whisky, held with consummate skill so that it did not interrupt the plume of smoke. "Drink?" was the password and the first line in any love scene: a glass lifted to the lips was an explicit sign stolen directly from the women's fans of the seventeenth century. Seduction therefore became the male prerogative; the technique used by the seducer, whether a beginner or expert, is almost always the same. The skirmish is always begun with the pretence of a conversation: males are advised to indulge in stories of their private life, whether true or invented, as long as they are short. Talk of sport or a story from the newspapers is acceptable, or perhaps some racy article taken from the crime pages, though this approach should be handled with care. Telling a secret is a good step, maybe a disappointment in love — always recent and always caused by a "loved but egoistic" woman, and throw in an allusion to culture (the last exhibition visited, book read, etc.) as evidence of a degree of intellect. The modern seducer, even an everyday gigolo, must either be or seem well-educated and cultured, appear indifferent to money (though he really loves it!), and have time free to dedicate himself properly to seduction. The only obligation of the professional male seducer is love. He is not a "man of power": these men do not need to seduce because they conquer. The seducer must create a role for himself, win the trust of a woman who may be argumentative, difficult, grim, sad, overly shy or too indiscreet, invasive, demanding or driven. The more difficult it is, the more the seducer is happy to battle, to test himself, and to win. "Would you like something to drink?" Uncertain beginnings: breaking the ice, warming the atmosphere, giving form to a plan that hints and glances have only delineated. Now that the male crisis of the final decades

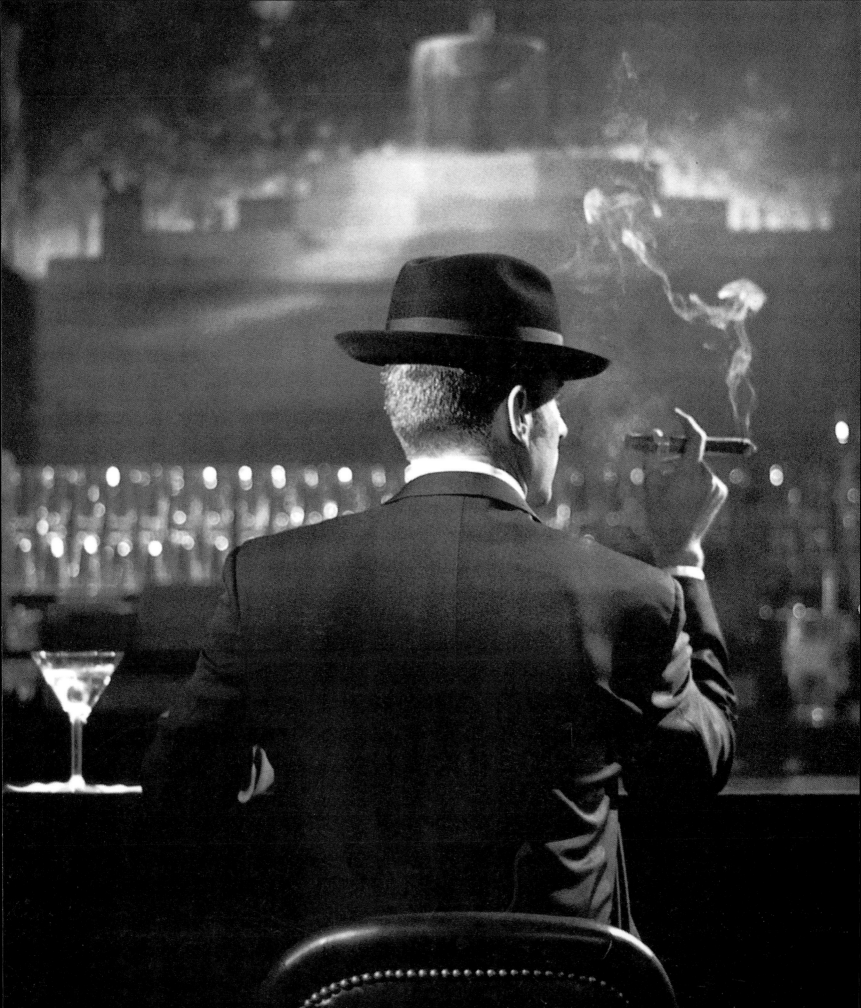

of the last century has passed, a crisis that also upset seductive strategies, the third millennium has shown that the men are unquestionably the seducers of the modern era. The erotic and sentimental proposals of women are too explicit to be considered as high seduction: the real performance is up to him. Men have developed a theory of seduction that does not, as it does for women, make use of superfluous exhibition. They have no need to show their body, nor to fall back on flirting, elaborate make-up, body sculpting, tattoos, plastic surgery, breast enlargement to a 36, 37... 40. In the ceaseless pace of our lives today, the modern seducer goes against the current: he is uncommitted, has time to walk, look around... and look at you. He has time to love, to play, to dream and to arouse dreams. He dreams little but enjoys his power of the art of seduction. He fears love, which he avoids by keeping clear of intimate conversation. He considers thoughts as the rhetoric of feelings; he prefers laughter to smiles, he flirts with irony, he gives nothing away and shares no confidences. He only has words about love and sex, perhaps in profusion. In this era of empty encounters, where money-making is king and a businessman will trade his soul to be quoted on the Stock Market or be able to enjoy exotic holidays, the seducer achieves his goal by dropping pauses into his speech, silences that suggest an inner dimension, some paradisical state to be explored. He wears elegant, slightly casual clothes. He is ambiguous, and refined in his behaviour; he makes promises and whispers possibilities with the looks of an assassin. He has long tango eyes, thick hair and a voice hoarse from making love, "trembling on the point of fainting"; he has large hands, long arms "to hug you better", he is tall, his footsteps stealthy, has a ready mouth against which he likes to hold a glass while staring at his new prey with the eyes of a hawk. In his code of love, sipping a high quality wine is a song, "... how I will drink you!". The ancient, eternal cocktail of Bacchus and Eros has been confirmed by recent studies as a high potential binomial in fashion in ancient Egypt. Researchers from the University of Manchester have discovered that matters of love were preceded by a ritual that suggested soaking lotus leaves (noted for their aphrodisiacal power) in the best wine to produce a sort of natural "Viagra". The ancient and eternal

CORNELIANI, SPRING/SUMMER COLLECTION 1986

game of seduction may have begun with the story of Adam and Eve. Was it not then that seduction, thought of as a female art, was expressed for the first time with Eve's sly, seductive proposal to the unwary, trusting Adam to try the apple of sin? But what if it was not actually like that? What if it had been him who convinced the unwary Eve to taste the forbidden fruit, thereby initiating her into the pleasure of knowledge with all the consequences that the Bible has handed down to us? Was it Adam who offered the seductive nectar to the innocent Eve when he offered her the apple of sin? Was Adam both the first man and the first seducer in history? Undoubtedly the seducer needs admiration to have the illusion of power (even if it is only the power of machismo). Professional "beauties", male models for example, look, or rather, gaze about as they parade, in search of prey to seduce: to have the pleasure of conquering, it does not matter who the victim is, provided you win, it does not matter what the prize is, and sometimes even conceding does not matter because it may increase one's self-esteem that lack of love does not protect from the truth. A trite phrase says that only wine is the friend of truth, so let's take a glass of elixir when playing the truth game to discover that the sworn enemy of seduction is love. The seducer wins as long as he is not faced, like Don Juan's stone guest, by a woman who Truly Loves him, who renounces the desire for victory, and is not interested in using strategies or tactics to conquer him, as, due to her love for him, she has already won the battle. Love has no need of bewitching glances, melodious tones of voice, exotic atmospheres, the sipping of wine in an erotic manner, or masochistic practices like drinking from a silk slipper. Such ruses are only for use in the loveless game of seduction.

LUCIANA BOCCARDI

"Women are beautiful
but so are men"

The authenticity
and elegance

approachable
for all occasions

Because, to be really elegant, the outfit must be "made to measure", not so much in the sense that it was created around the wearer as — something beyond fashion — it is suited to his physical type, his character and his personality.

CASUAL ELEGANCE. FASHION IS RENEWAL AND TRANSFORMATION. THE MORE OUTFITS PEOPLE HAVE, THE MORE CHARACTERS THEY CAN IMPERSONATE.

*"Il possède une qualité lumineuse
qui le rend unique,
dans le registre de la mode,
de la fantaisie, de la magie,
de la beauté — il ose nous faire rêver."*

STÉPHANE MARAIS

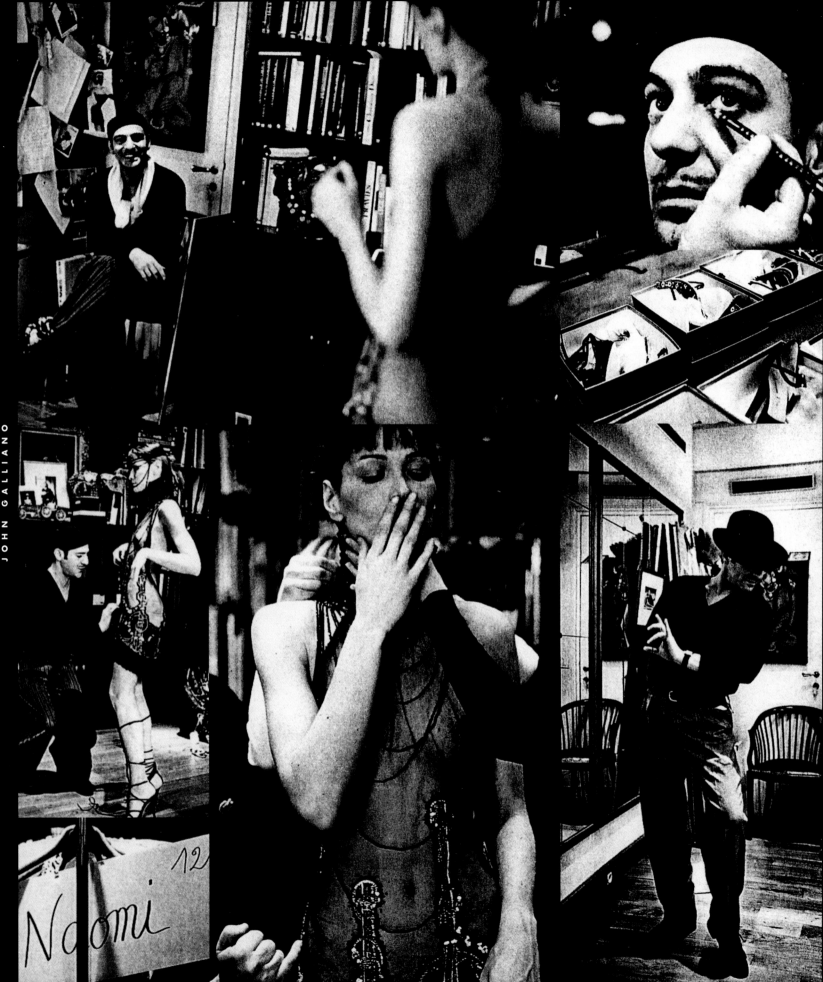

Naomi

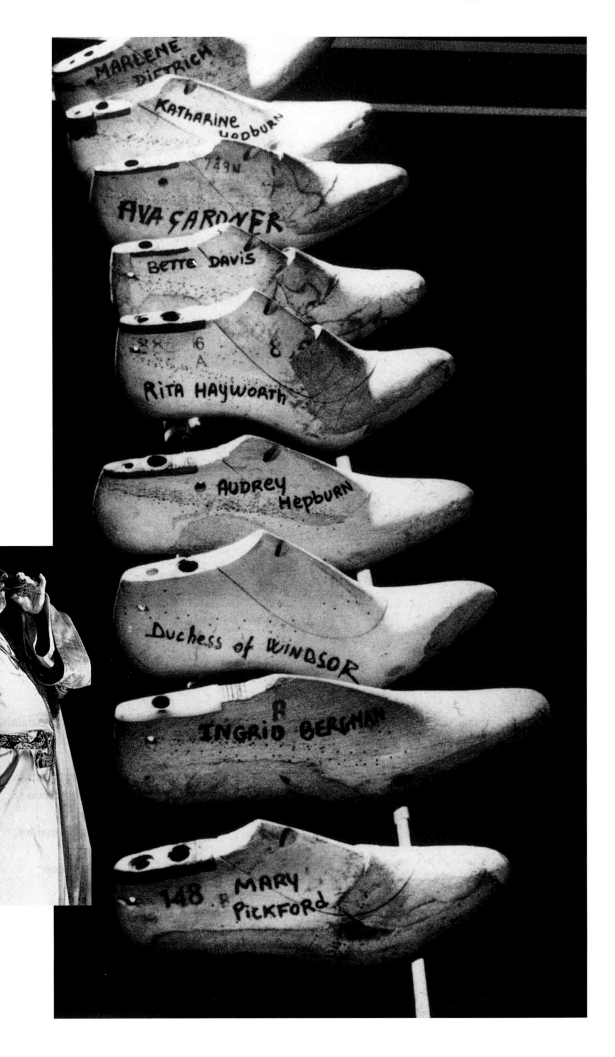

PAUL POIRET
dressed as a sultan in a Persian-style party

126

Haute Couture

CHRISTIAN DIOR
at Moulin du Coudret, Milly-la-Forêt

*Christian Dior, un seigneur de la Renaissance,
attardé sur notre planète en cette fin du XXᵉ siècle.
Un homme qui possédait le sens et le culte
du beau, toujours à la recherche de la perfection,
homme d'esprit et de cœur, fin gourmet,
pour qui les choses de la table
et de la gastronomie étaient œuvre
de Dieu et des hommes.
Il m'honorait de son amitié, et j'avais toujours
plaisir à accueillir cet homme aimable,
courtois, qui dans les mets recherchait
non seulement les subtilités, les nuances,
mais aussi et surtout les accords,
pour un juste équilibre, dans une parfaite harmonie.
Il avait le sens de la cuisine, il en était passionné.
Il me souvient qu'un jour, lui ayant préparé
et servi des œufs brouillés aux truffes,
il me dit: "Raymond Thuilier, c'est irréel
et grand par sa simplicité. Rendons gloire
et hommage à celui qui dans son infinie bonté
a mis la bouche près de l'esprit."
Combien il avait raison. La satisfaction
gourmande n'est-elle pas déjà dans la vision d'un plat?
C'est en effet dans la recherche de la simplicité
du beau et de la qualité que l'on découvre
les vraies valeurs humaines, source du génie,
des meilleures et des plus grandes joies.
Il parlait d'un vin comme d'une élégante et belle fille.
"Ce vin a du corps, de l'esprit et du jarret.
"C'est un vin amoureux, qui est ferme
sans être dur, et câlin à souhait."
Il comparait très volontiers la cuisine,
et la passion qu'il en avait, avec son métier.
"Les matériaux en cuisine sont aussi nobles
qu'en couture, et ce que j'aime dans l'exercice
de ma profession, me disait-il, c'est l'association
à la réalisation de l'œuvre de la participation
des mains et de l'esprit. J'éprouve en cuisine
les mêmes sensations, et si la cuisine
est une œuvre de l'intelligence, les mains
en sont les exécutantes fidèles,
car la réalisation d'une œuvre ne peut être
parfaite que si l'imagination créatrice
est associée d'une façon fidèle aux mains."
Les qualités d'une sauce ne révèlent-elles pas,
déjà, au toucher, le plus subtil des sens...?
J'évoque très souvent la belle et noble figure
de Christian Dior, amoureux de son métier,
il fut grand parmi les grands.*

RAYMOND THUILIER

A Cup of Wine:

an unmatchable accomplice in erotic high spirits

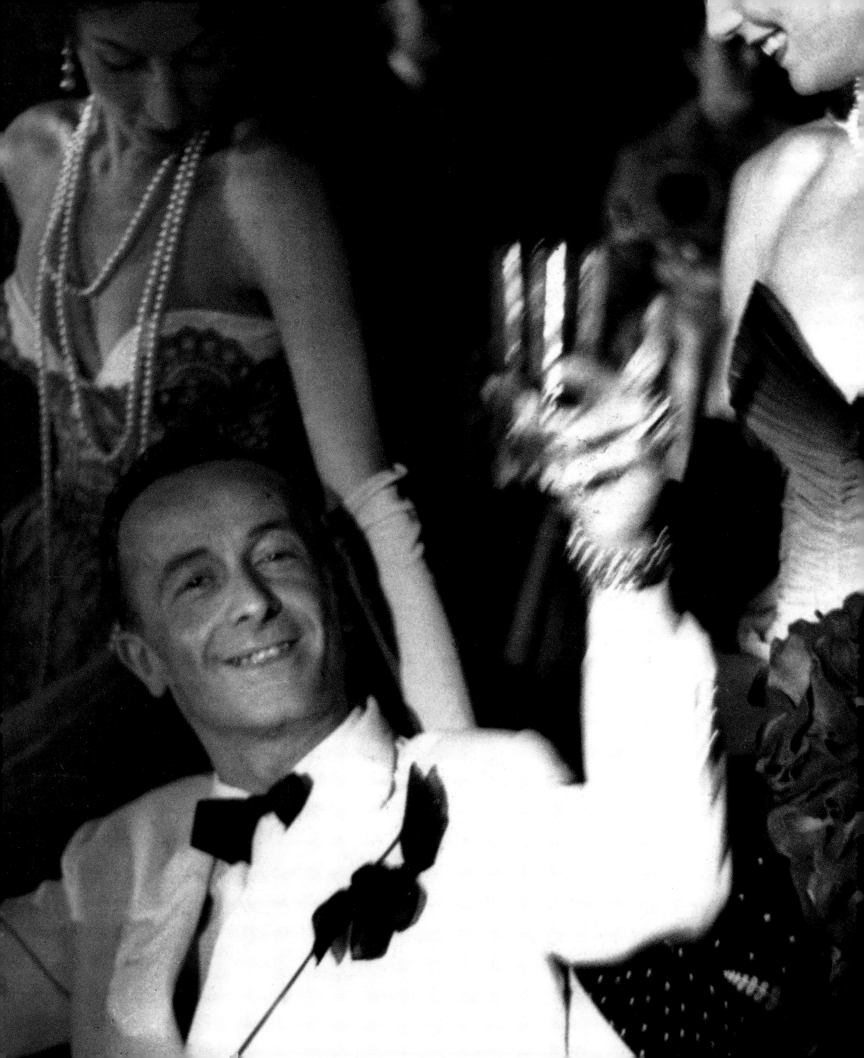

Le rouge et le noir

WHY RED?
THE FIRST OVERRIDING TEMPTATION
IS A SIMPLE AND BANAL REPLY.
BECAUSE IT'S NICE. IN FACT, THERE IS SOMETHING DEEPER,

something that lies not just in the depths of the individual's psyche, but in the consciousness of man who has always been passionate about red. It was thought that red protected us from danger, with the result that animals, plants and objects were painted red to keep them from the effects of the Evil One, or to make things fertile. As a colour it also symbolises evil, fire and war. Yet it also represents passion (is there anyone who does not dream of receiving a dozen red roses?). To Egyptians, red was a danger signal, the symbol of the desert that kills and of burial places. Scribes even used red to write unpleasant words. Executioners often wore red, but also judges, not to mention cardinals. But even in the Apocalypse in the Book of Revelations, the mother of all harlots, Babylon, wore purple and scarlet clothes and rode a seven-headed beast, the bringer of all vices.

IN THE END, THOUGH, RED IS THE COLOUR OF PASSION,

at least to our society, but of all these symbolic and mysterious meanings, two stand out in particular. Krasnaya Ploshad. Said like that, its meaning is not clear, but it is Russian for Moscow's Red Square. Not red because it was created by Communism but because *krasnaya* means both red and beautiful. This

powerful colour also represents fresh life, the arrival of the new, and its choice as the symbol of the revolution is quite logical. Here is the explanation why, when wearing a red dress, one feels one is reborn. Before having the power to seduce, one must be at least a bit convinced that one has the power to do so. Red helps and others are aware of it. They sense that certainty that this magnificent colour transmits to both the wearer and the observer. If red is the choice of a talented clothes designer, and he combines this colour with perfect style and a perfect cut, then everything coincides and everyone can feel beautiful.

CESARA BUONAMICI

EROS DRINKING WINE.
THE INTRIGUING RELATIONSHIP BETWEEN BACCHUS AND VENUS

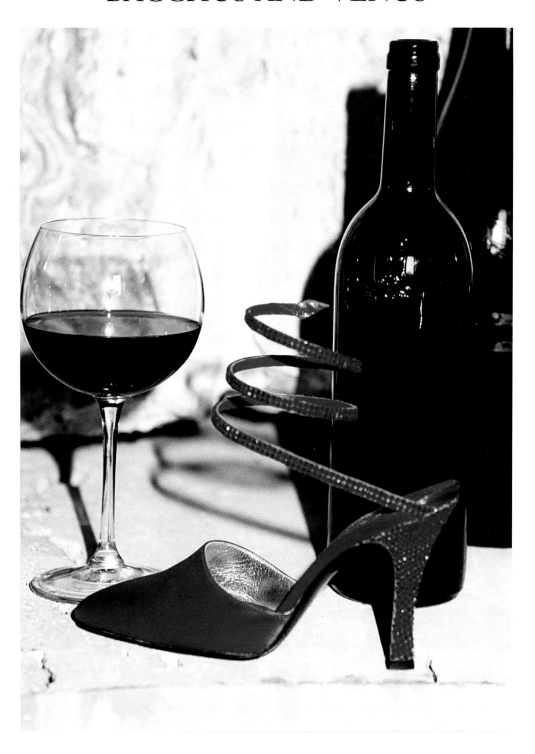

Shoes are the aesthetic form of eroticism.
The essence of sensuality.

Rojo encendido

…No hay aquí sin luz,

cantidades, racimos,

espacio abierto

por las virtudes del viento,

hasta entregar los últimos

secretos de la espuma…

…Yo soy el que en los labios

guarda, sabor de uvas,

Racimos refregados,

mordeduras bermejas,

Yo soy el que en la hora del amor,

te desea…

PABLO NERUDA

Drawing by Mats Gustavson / Archivio Valentino

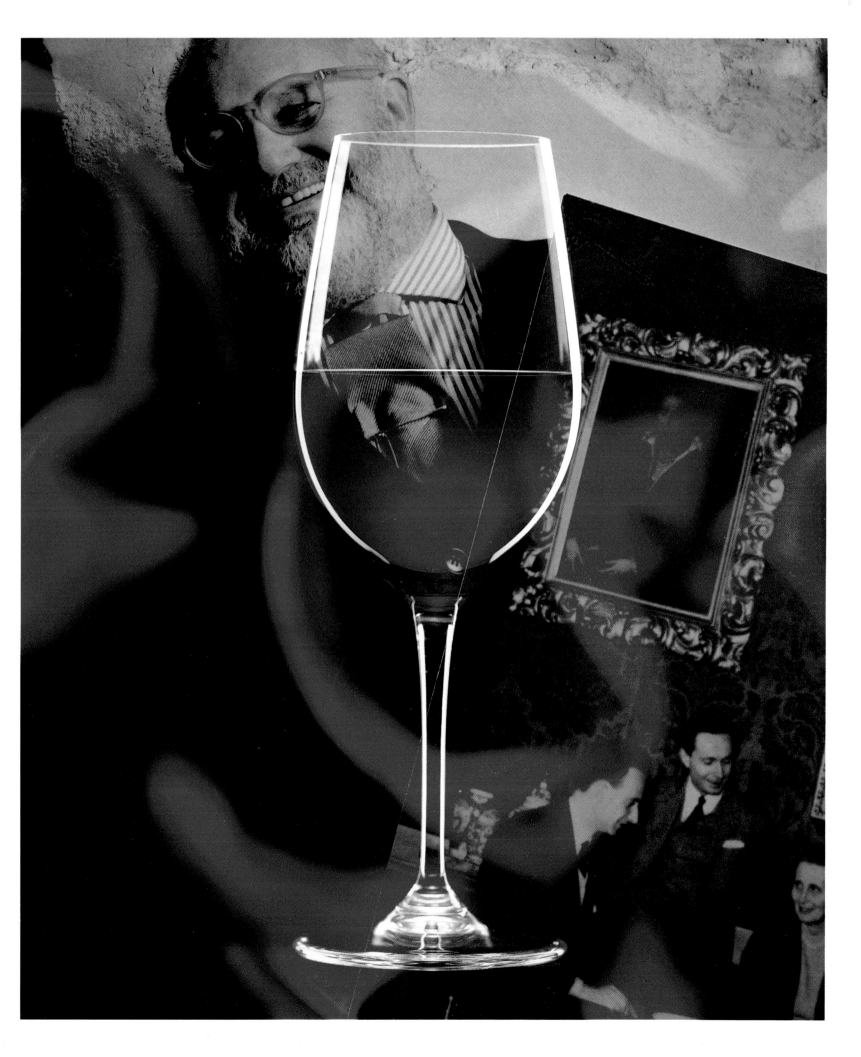

BLACK IS THE BEGINNING OF EVERYTHING AND NEVER REPEATS ITSELF.

A CHROMATIC ICON THAT ACCOMPANIES and reinforces elegance. Colours are energy, electromagnetic vibrations. Black is the Negation of the entire Rainbow. It is an attempt to protect oneself from the gaze of others. Black is a colour of respect, tradition and significance. It has always been considered the colour of mourning, tragedy and sadness. But with time, its use has become far wider and its identity more varied: in European courts it was a sign of extreme elegance, in literature it was an aesthetic cipher for great poets of the nineteenth century like Ugo Foscolo and Baudelaire; in the twentieth century it became the symbol and uniform of thought-battles, of the existentialism of Jean-Paul Sarte and Juliette Gréco, the life-art-life of Pop Art, the aesthetics of the Velvet Underground and the "no future - no dream" fetish of the punk movement. It is a way of expressing identity. Black is the colour that unites opposites: elegance, uniformity, distinction, internal distress, but also lucidity and self-control. Black attracts and distances, it alludes to a tightly-closed personality but also to a deeper and more intriguing dimension.

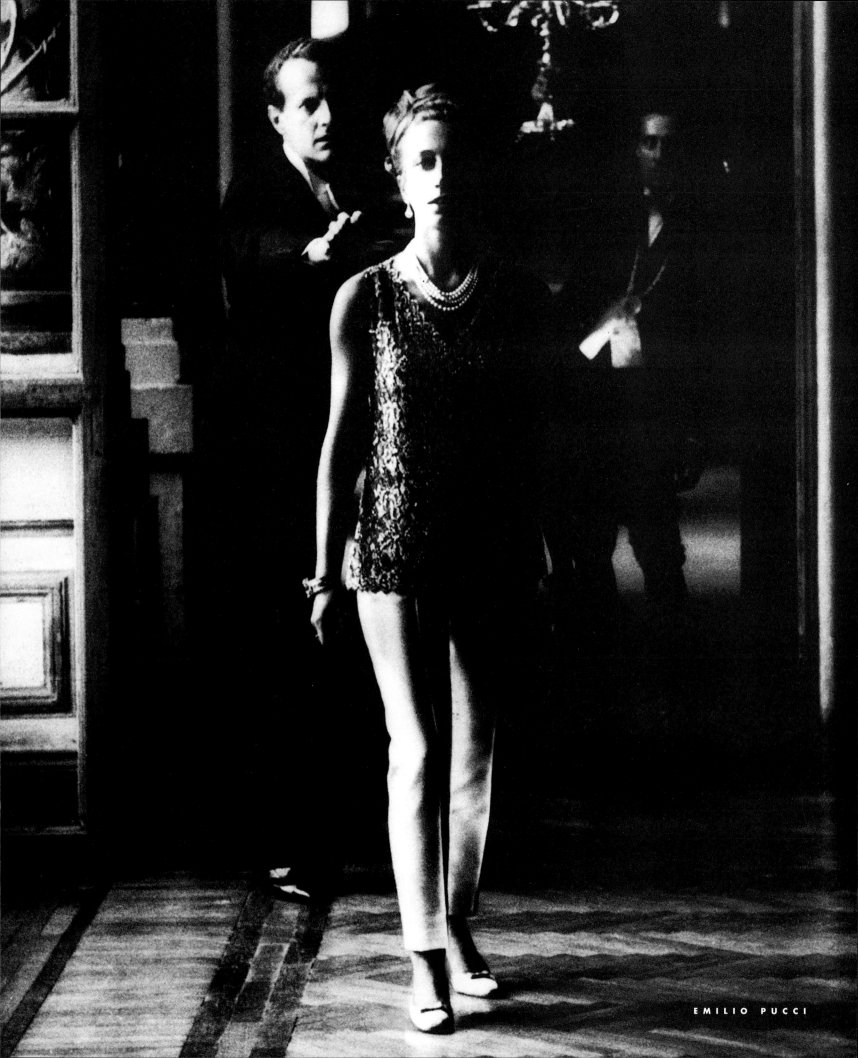

EMILIO PUCCI

GOD ONLY CREATED WATER,

VICTOR HUGO WROTE, BUT MAN MADE WINE. AND HERE IT IS, IN ALL ITS EXUBERANT MAGNIFICENCE, THE DELICIOUS PRODUCT OF OUR VINES.

What adjectives are suitable for a drink so noble it became a fundamental element of the Christian religion? None that has not already been used. But take a look at the masterpiece by Franz Hals, *The happy drinker*, and you will find there his philosophy: the effervescent smile of the wise man who cheerfully toasts the boring run of life. This is the effect that good drink brings. It is not true, as Horace claimed, that the ancient wine Falerno was able to do away with all worries. However, wine is able to temper our sadness, soften our feelings of solitude, strengthen our dynamism, and inebriate our few moments of happiness. Wine changes like our own volubility: fresh and perfumed under a summer sun, strong and well-bodied during November's mists, exciting in the euphoria of a toast, confidential when sipping ritually and alone, and always a sincere friend that encourages us to serene reflection. It is a fruit, as the Church teaches us, of the land and human toil, and reconciles us with the cruelty of the former and the disappointments of the latter. Its soporific smoothness mitigates the sadness of our spirits, makes us calm and meek in the face of the lessons nature has to teach us, and helps us to put up with reality in a more disenchanted and kindly manner. Things of beauty also have this function. Man's artistic creations are not only representations of ideas or the developments of feelings. They are a salutary refuge for those who wish to leave, at least for a while, the monotony of daily life. The word "diversion", from the verb "divert", means to move away from, i.e. to face elsewhere: our greatest joy is formed when we forget our unhappy condition. The catharsis of tragedy, the lyrical intuition of poetry and the ecstasy of music are all moments of abandon when we leave the world of experience for the world of imagination. The creations of the fashion world are also artistic derivations of our creativity. Though part of a smaller world, they are part of the laws of aesthetics and their redeeming functions. They complement the beauty of the human body in the same way that wine complements food: they extol qualities while diminishing imperfections. And lastly there is an undefinable tactile pleasure in the tasting ritual. Opening a bottle of fine wine gives cultivated individuals the same sensation (a little fetishistic) that bibliophiles enjoy when cutting the pages of an old book. It is a feeling of exclusivity, of surprise and novelty. Are these unimportant? Perhaps. True joy often springs from unimportant things. On this, in the wide and learned philosophy related to wine, the best commendation is by Molière, though please excuse my rather perfunctory translation:

les biens, le savoir et la gloire	*Wealth, knowledge and glory*
n'ôtent point les soucis fâcheux	*Do not do away with annoying problems*
et ce n'est qu'à bien boire	*It is only enjoying a good glass*
que l'on peut être heureux	*That we can be happy*

CARLO NORDIO

"Le plus important,
 c'est la curiosité"

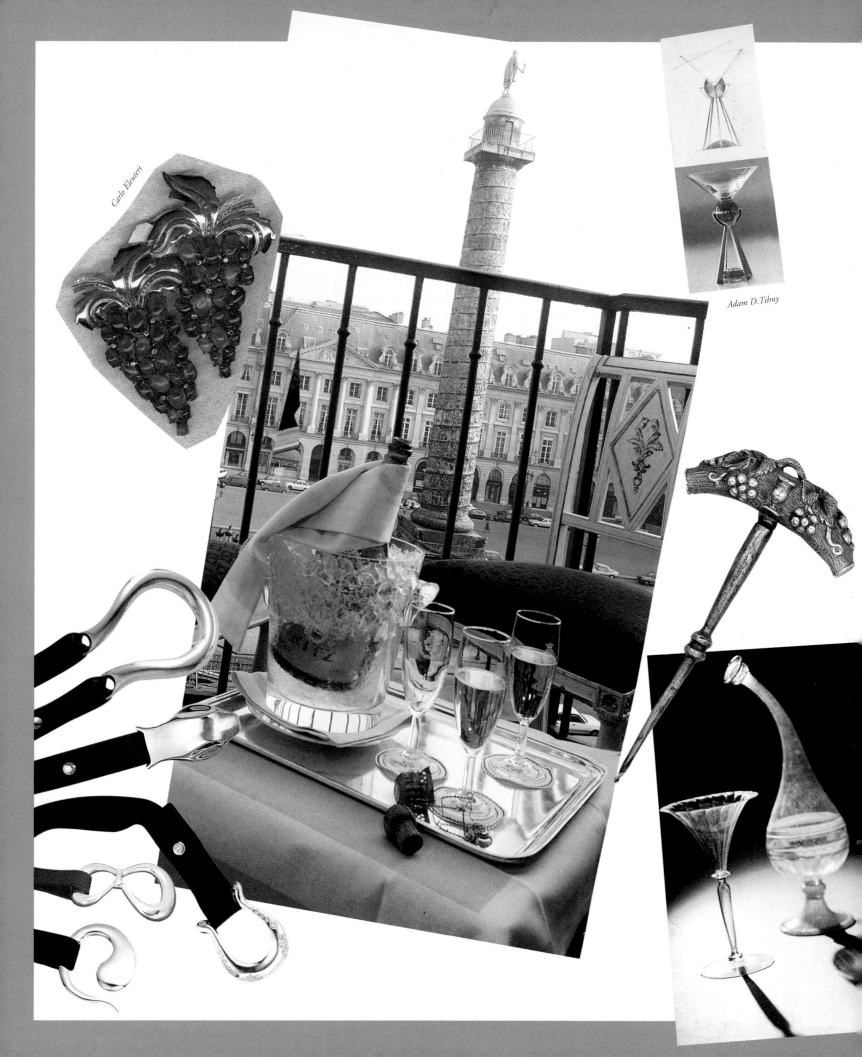

Carlo Eleuteri

Adam D. Tihny

The Accessory

Elimina
l'Anidride
Solforosa
Durante la
Mercita
del Vino

"Sphera" in ottone argentato

Progetto
CANTINA
ARREDO

Trois allumettes
une à une allumées
dans la nuit

La première pour voir
ton visage tout entier
la seconde pour voir tes
yeux
la dernière pour voir
ta bouche

Et l'obscurité
tout entière pour me
rappeler tout cela
En te serrant dans
mes bras.

J. Prévert

BICHIEROGRA
FIA

*Diliniata da Giovanni Maggi
Romano, Pittore*

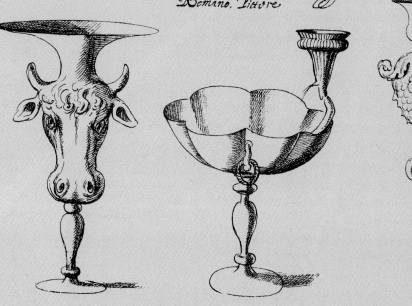

*Let us drink! Why wait for the lamps? There is only a sliver of daytime left.
Friend, get down the two golden cups: Dionysus gave men wine so they could forget their ills.
Mix them in proportion of one to two, fill the cups to the brim, and let one chase the other away*

ALCAEUS

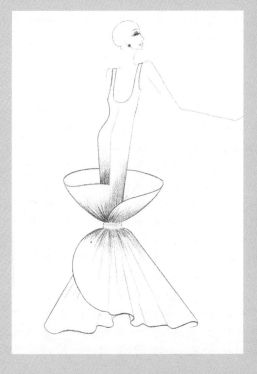

PARIS, 1984
Drawing by Stefano Canulli. Capucci Historical Archive

PARIS, 1984
Drawing by Stefano Canulli. Capucci Historical Archive

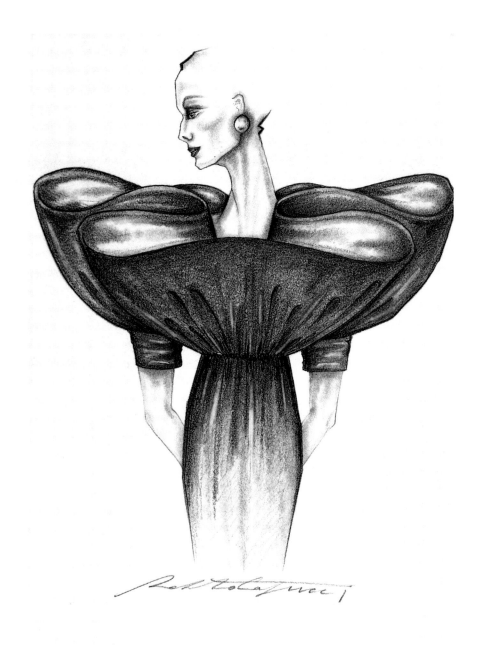

CUPS, 1985

violet satin and turquoise lining
Private collection. Autograph drawing by Roberto Capucci

Cheers!

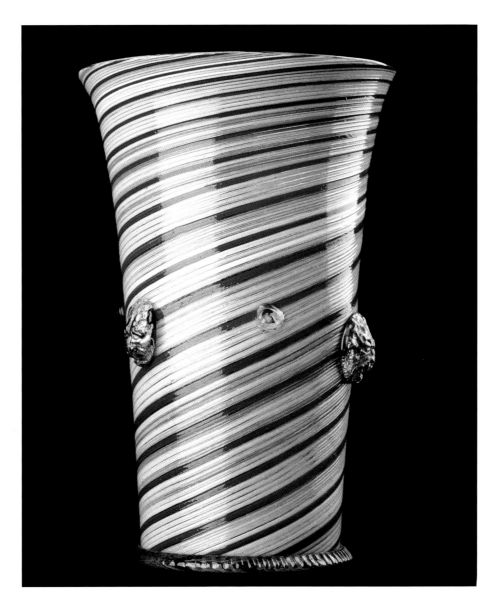

Gems created in fire

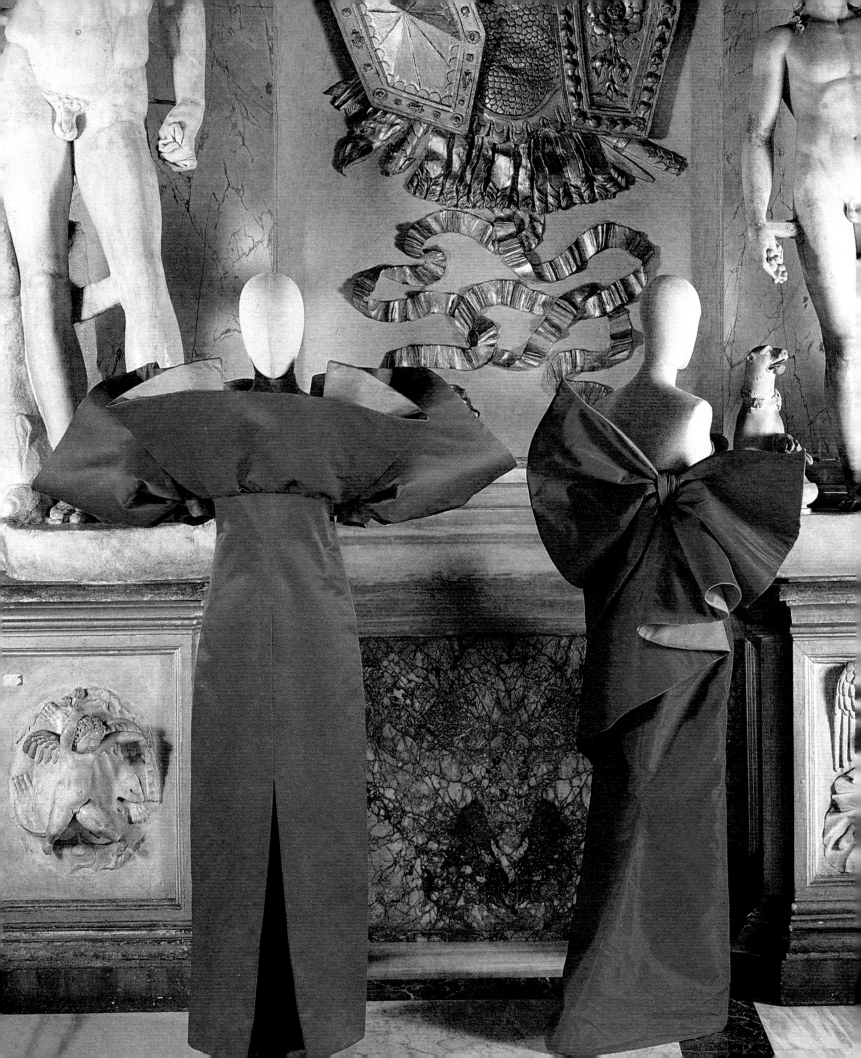

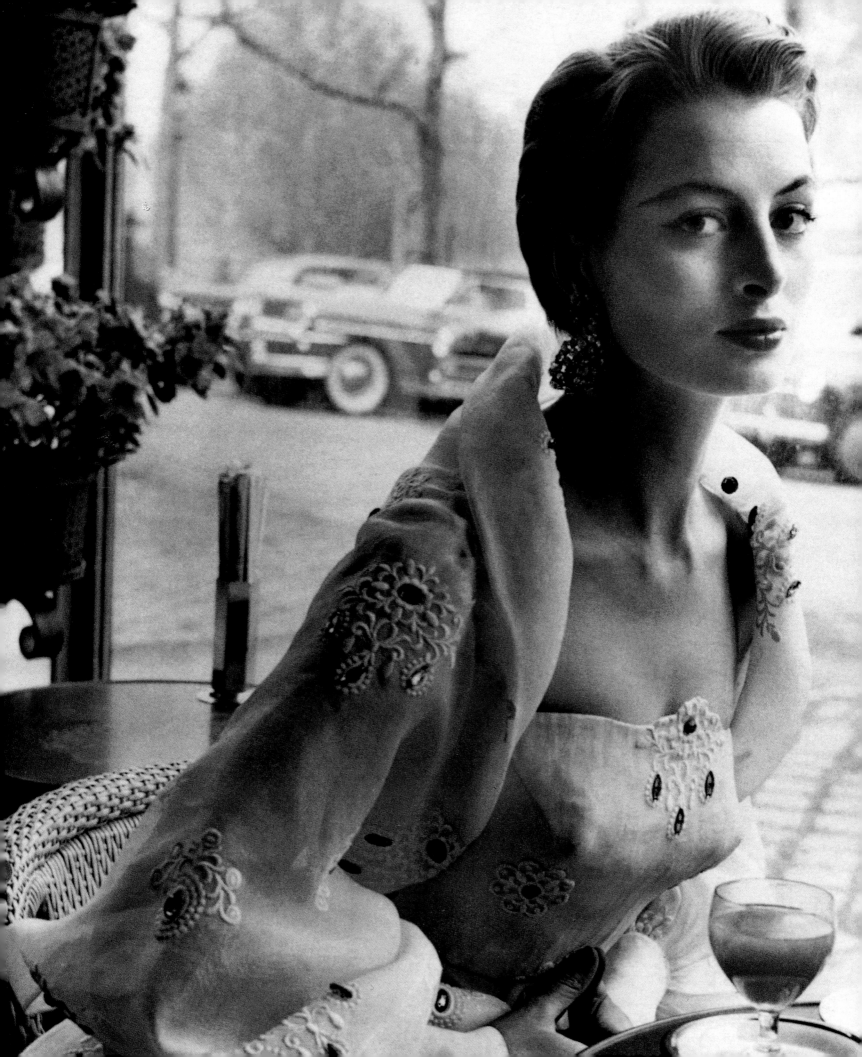

The Joy of Wine

HUBERT DE GIVENCHY

Et les verres
étaient vides
et la bouteille
brisée
Et le lit était
grand ouvert
et la porte fermée
Et toutes les
étoiles de verre
du bonheur et de la
beauté
resplendissaient
dans la poussière
de la chambre mal
balayée
Et j'étais ivre mort
et j'étais fou de
joie
et toi ivre vivante
toute nue dans
mes bras

J. Prévert

BBF

Haute Couture: even the Bottles are dressed fashionably

The important thing
in life is
to see that

the Glass
is Always
half Full!

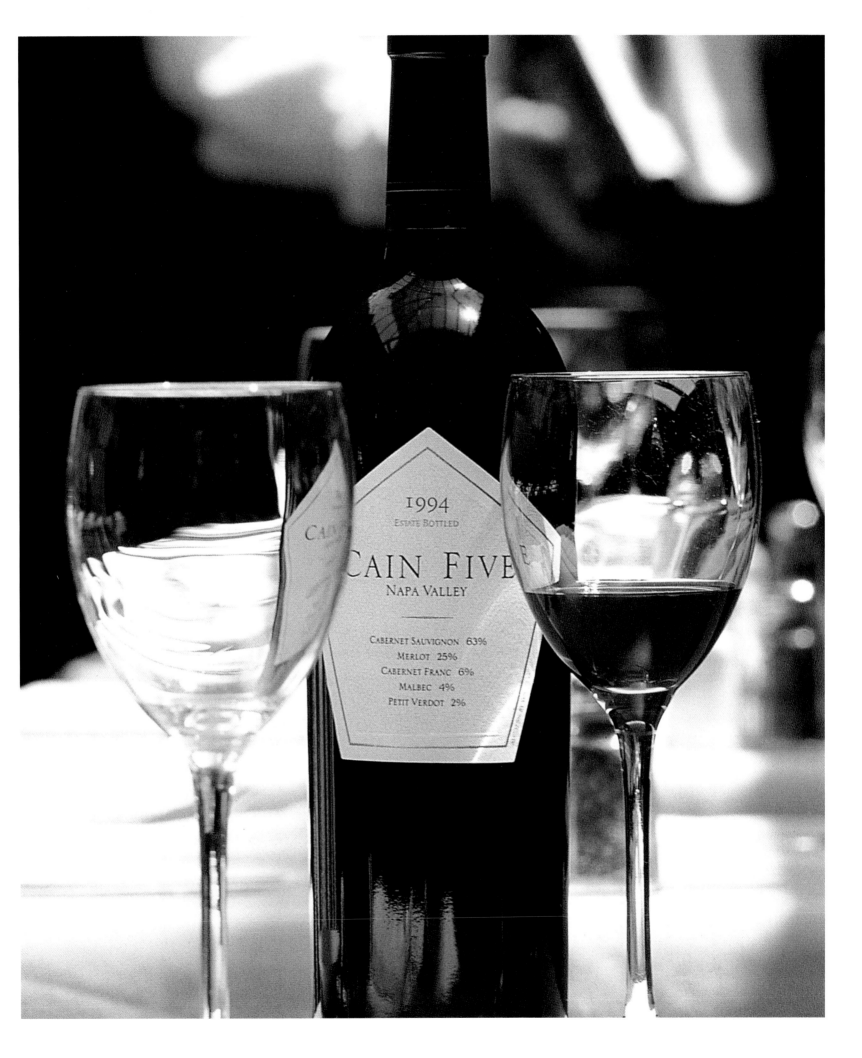

"LA QUALITÉ D'UN GRAND CRU EST ENGENDRÉE
PAR LA CONVERGENCE DE FACTEURS NATURELS
ET HUMAINS. C'EST LE PRODUIT DE CETTE
RENCONTRE OÙ, GRÂCE AUX PATIENTES VERTUS
DE L'EMPIRISME, RIEN NE PRÉDOMINE, RIEN
N'EST ESSENTIEL MAIS TOUT EST NÉCESSAIRE."

SAUTERNES

*"Des lieux où le Ciron en serpentant bouillonne
Et vient mêler son onde aux flots de la Garonne,
On voit se dessiner en groupes gracieux
Les monts où s'élabore un nectar précieux.*

*A droite, on aperçoit la sinueuse chaîne,
Bordant comme un feston le fleuve d'Aquitaine;
A gauche, des coteaux, qui bordant l'horizon,
Paraissent dérouler des tapis de gazon.
De gothiques châteaux, élevés sur leur crête,
Au loin, de leur pignon montrent le sombre faîte.
Que leur nom soit modeste ou leur blason altier,
Chacun d'eux est fameux dans l'univers entier.*

*Qu'ici le voyageur en passant se prosterne,
Car ces coteaux sont ceux de Bomme et de Sauterne !
Sauterne ! A ce seul nom, le gourmet enflammé
Sent déjà son palais de parfum embaumé."*

PIERRE BIARNEZ
Poèmes sur les vins de Bordeaux, 1849

"Ceci est une mosquée, un harem, un palais, si vous voulez. Mais, par Mahomet ! ce n'est pas un château, et, du reste, cela fait son éloge. Dans ce bon pays girondin, il y a tant de soi-disant châteaux que cela fait du bien de rencontrer ce petit palais oriental. Ça repose.

[...] Avec quelques sultanes et pas mal de négresses, [...] ce serait une merveille. Mais ça manque de palmiers [...]. Il en faut absolument, fussent-ils en zinc." Bertall, dans "Voyage autour des vins de France", paru au siècle dernier.

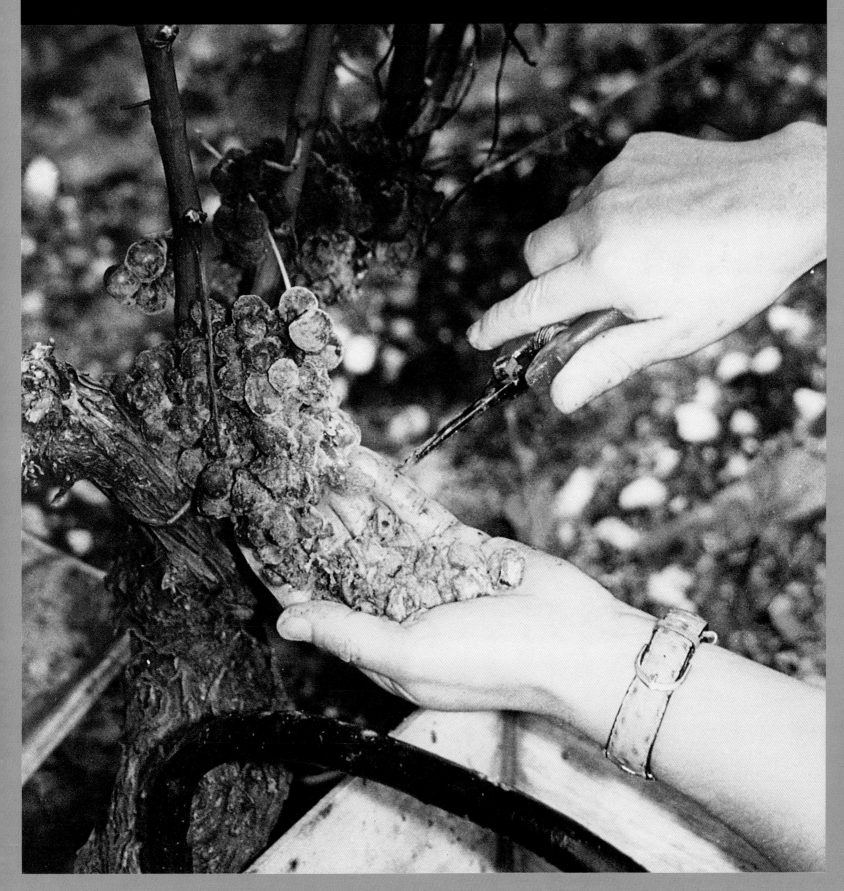

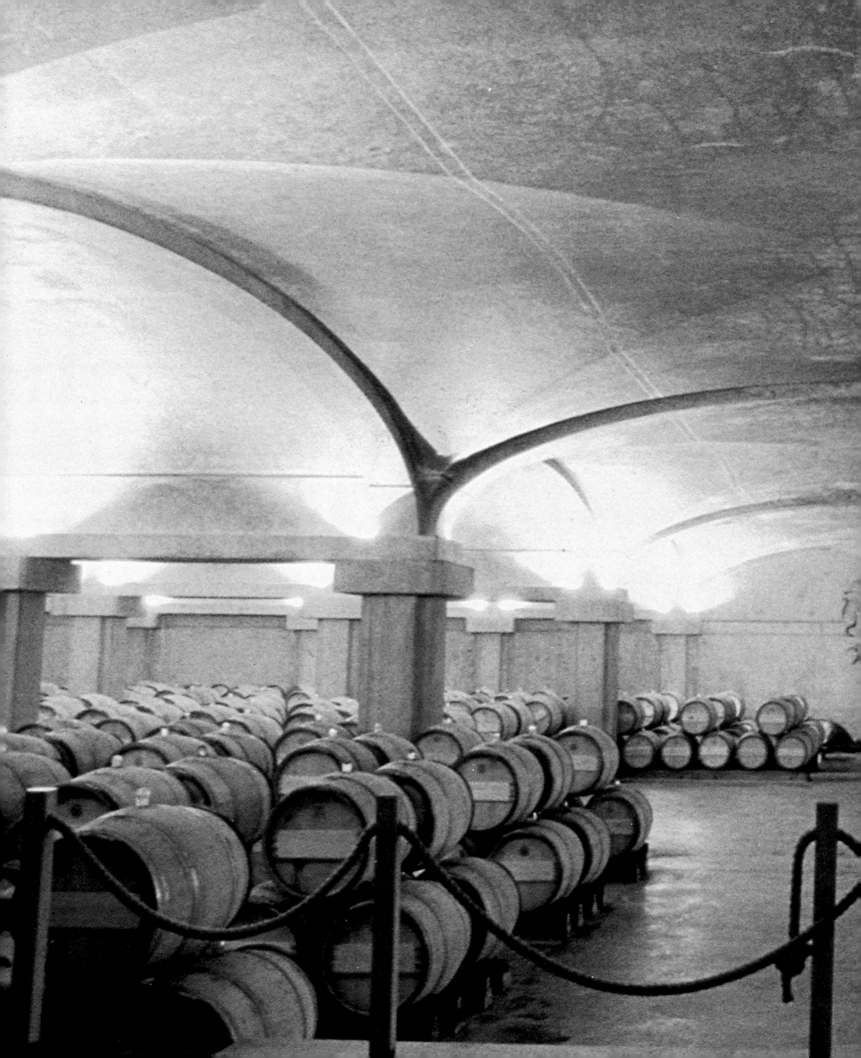

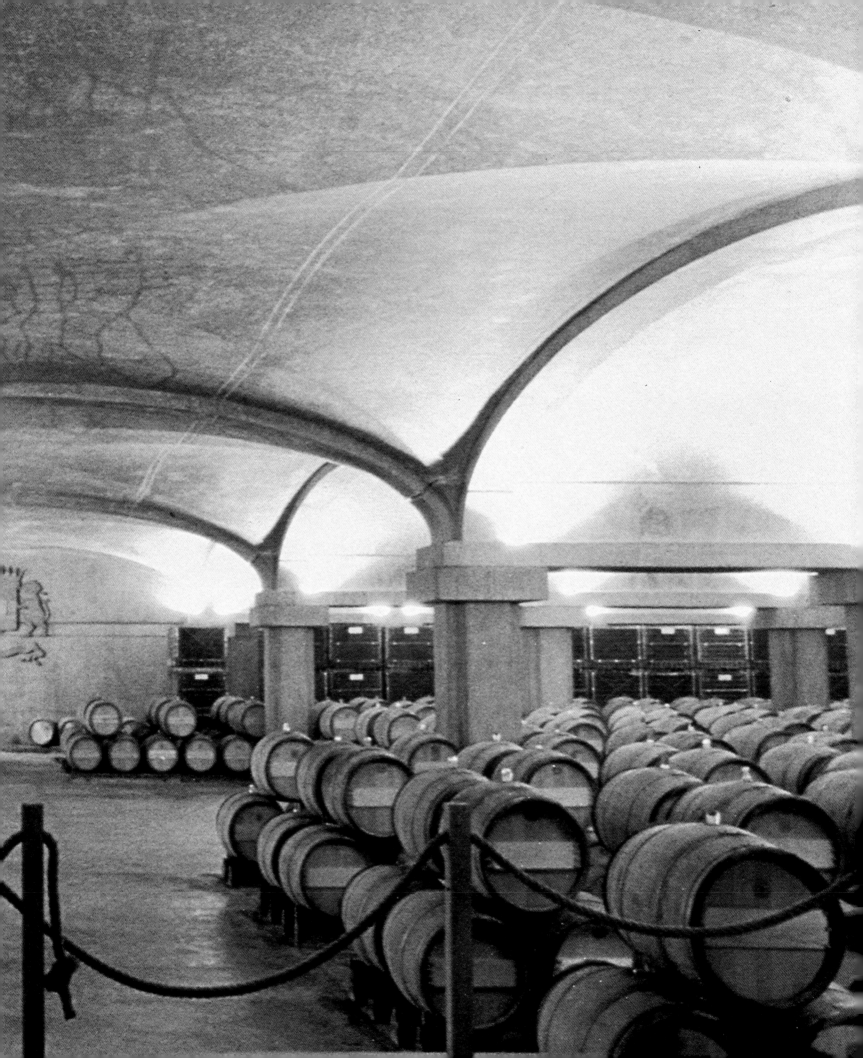

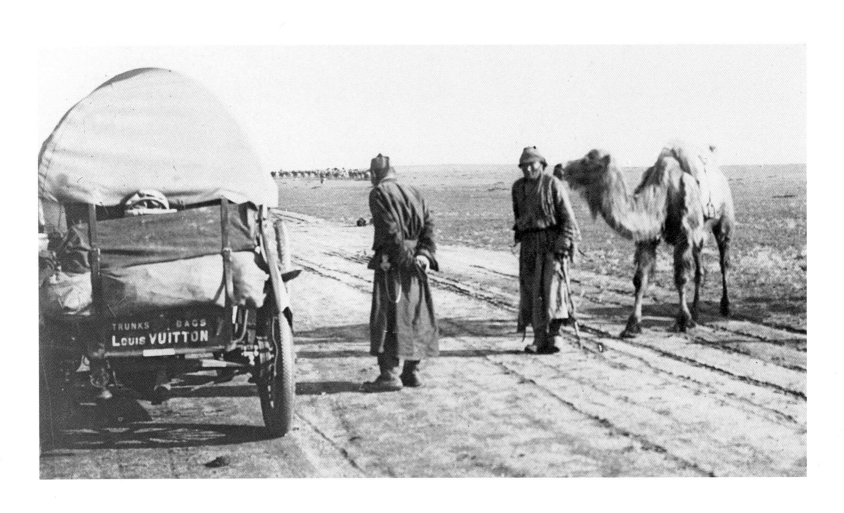

Participants in the first Paris-Peking rally, 1908. Gobi Desert, temperature 35° C

Only original, unmistakable style makes a mark

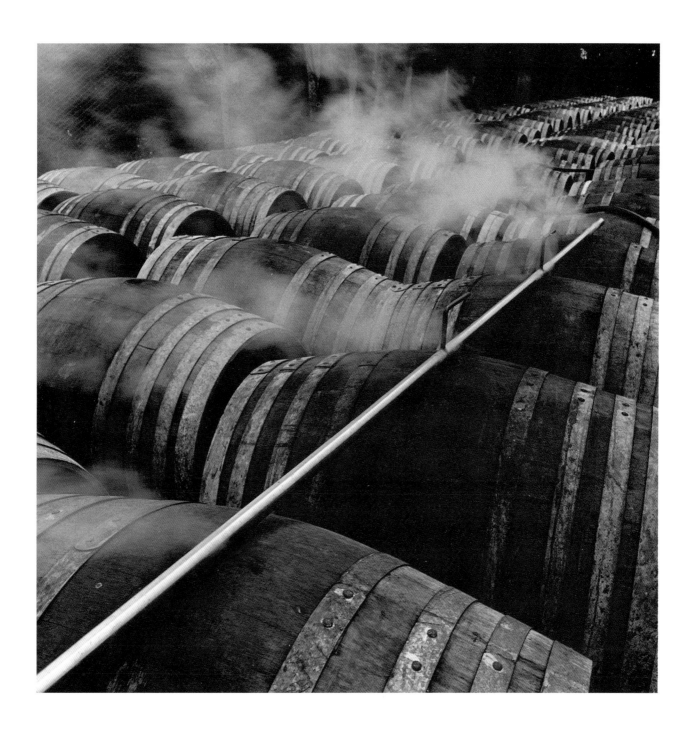

Barrel washing in San Guido

An exacting style

CELINE, 2001

A language of signs

Champagne

anytime, anywhere

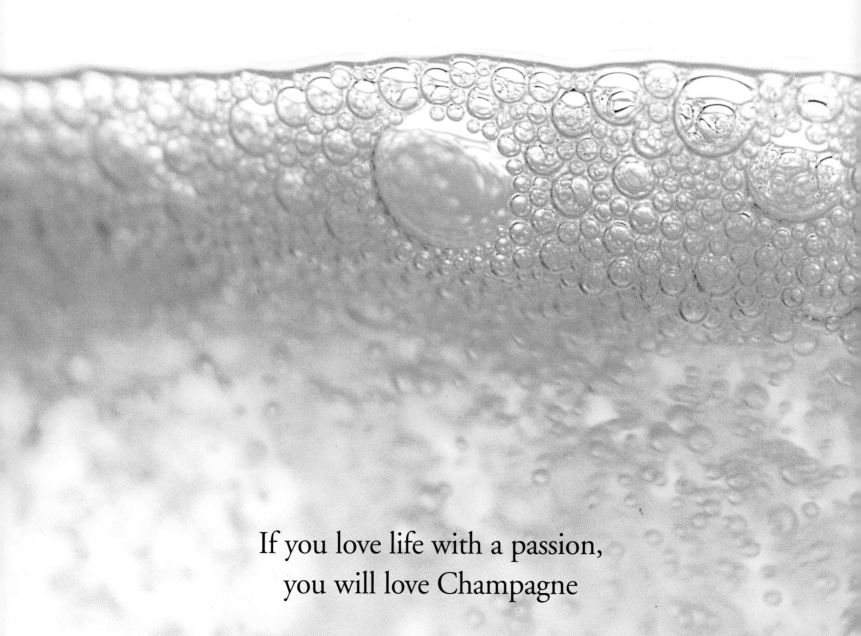

If you love life with a passion,
you will love Champagne

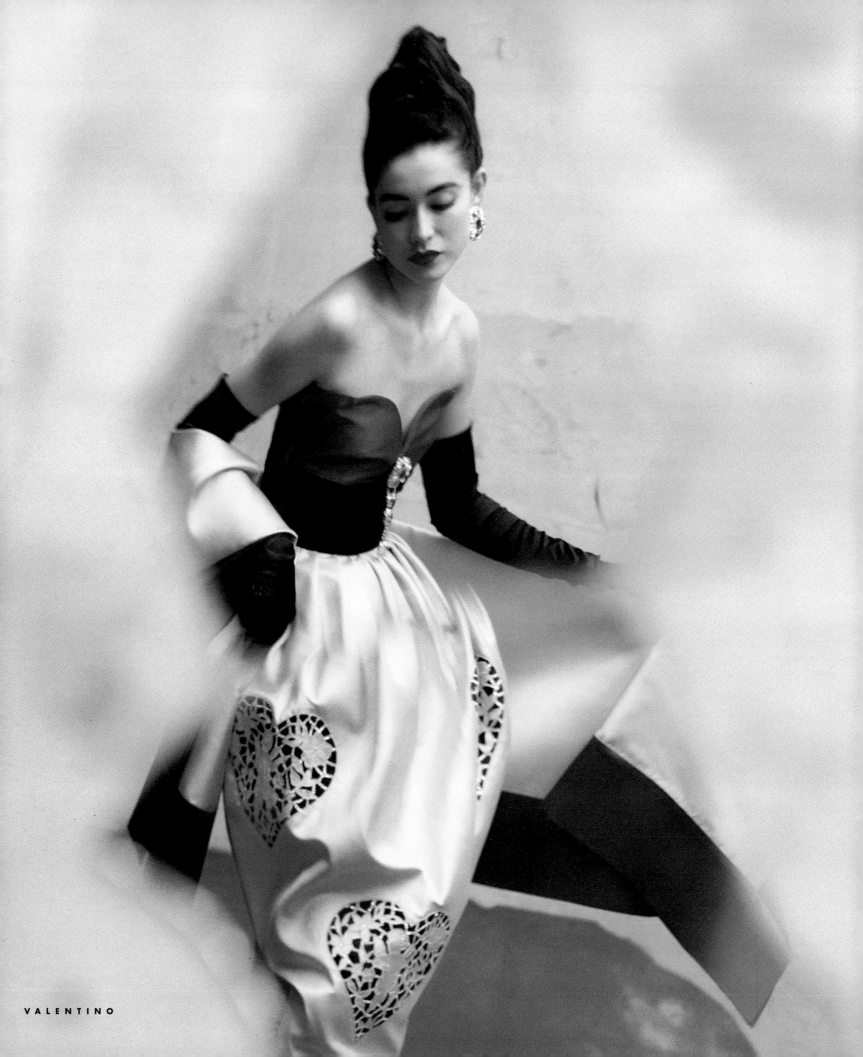

VALENTINO

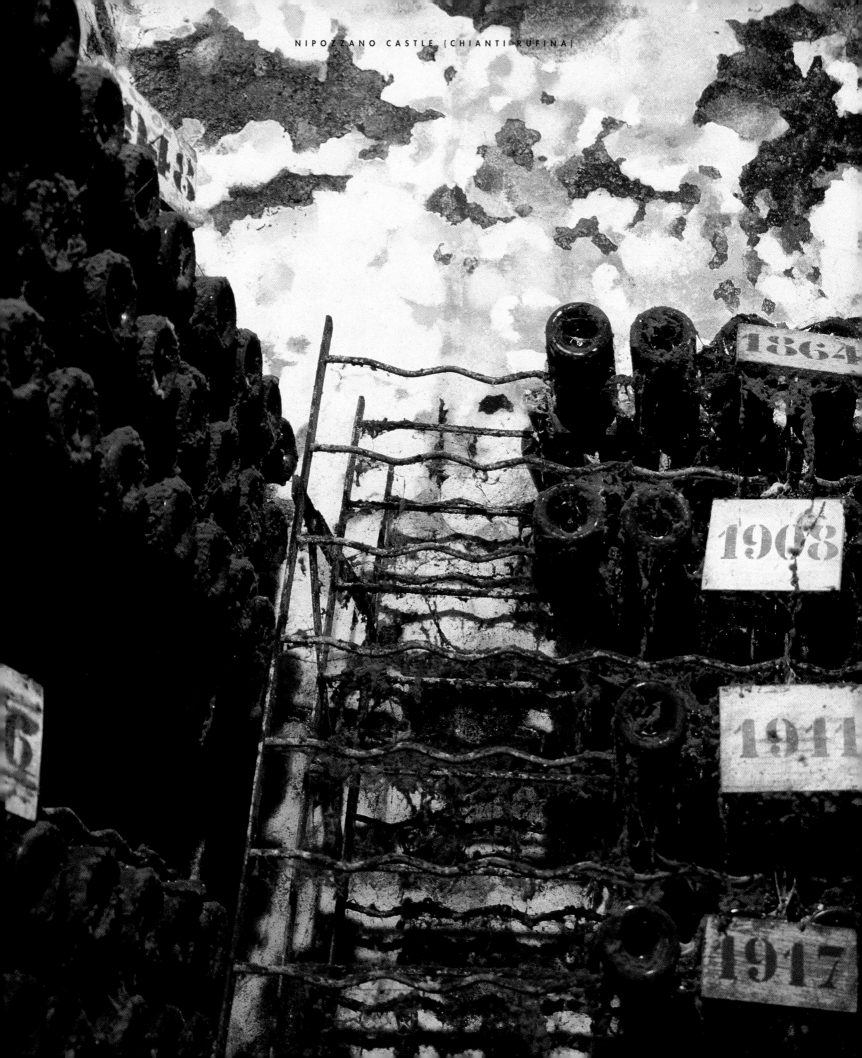

UNGARO

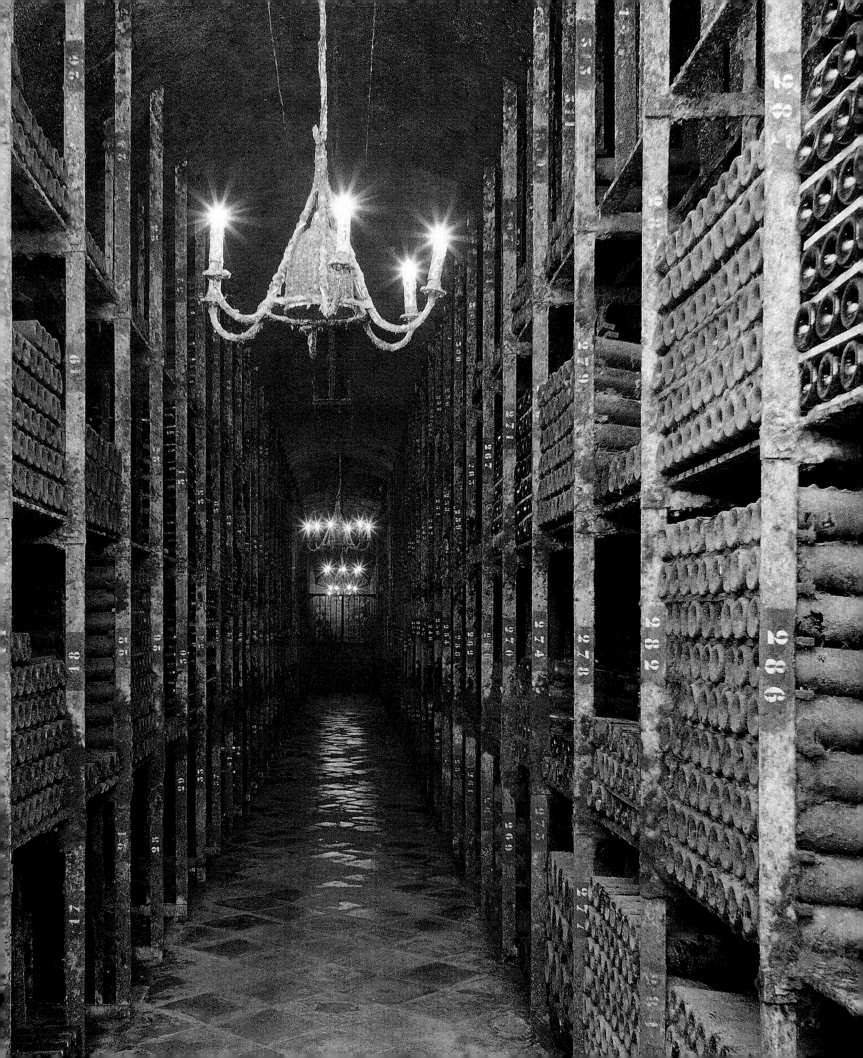

Objects of *Desire*

PASSION is contagious. From one you pass to another.
The secret is to live PASSIONATELY

Wine Collecting

HEIDY MARTINELLI
Bunch of white grapes and "diamond" yellow sapphire brooch

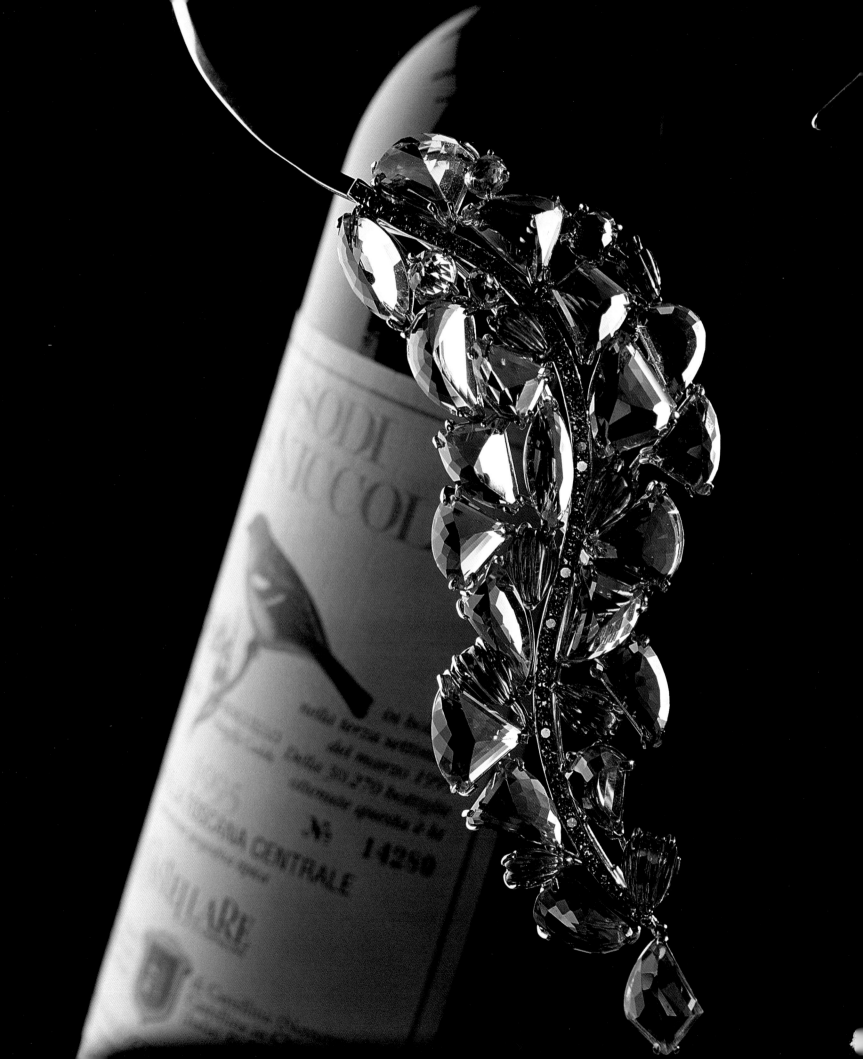

My Fashion

Château Lafite Rothschild Pauillac
Henry Bonneau, Reserve des Celestus Chateauneuf du Pape
Château Cheval Blanc, Saint-Emilion
Barbaresco Sorì Tildin 1982 Magnum
Château Climens 1947 Sauternes
Frères Focault Saumur Blanc 1921
Domaine J.J. Prum: Wehlener Sonnenuhr Riesling Trockenbeerenauslese
Barolo Bartolo Mascarello 1964
Château Haut Brion, Pessac-Léognan
Paul Jaboulet Ainé, Hermitage La Chapelle
Valpolicella Amarone 1985 Quintarelli
Château Latour, Pauillac
Château Rayas, Chateauneuf du Pape
Domaine de la Romanée Conti 1929
Château Haut Brion 1959 Pessac-Léognan
Brunello di Montalcino 1985 Lisini
Diamond Creek Gravelly-Meadow cabernet-sauvignon 1984
Château Mouton Rothschild 1945 Pauillac
Sassicaia 1985 Marchese Incisa della Rocchetta
Angelo Gaja, Sorì San Lorenzo 1996
Clos de Lambrays, Morey-Saint-Denis
Alto Adige Lagrein Dunkel Ris Josephus Mayr 1995
Louis Latour Corton-Charlemagne 1959
Penfolds Grange 1990
Grammonte 1999 Cottanera
Château du Beaucastel Roussanne Vieilles Vignes 1995
Vin de Constance (South Africa)
Castellare Sodi di San Nicolò 1985

Cellar

Infinito 1998 Lionello Marchesi
Blandy's Malmsey 1880 Madera
Solaia 1997 Antinori
Montepulciano d'Abruzzo 1988 Edoardo Valentini
Château D'yquem Sauternes 1893 Lur-Saluces
Tyrrel Val, Semillon, 1994 Hunter Valley (Australia)
Altesino, Brunello di Montalcino Montosoli 1995
Barolo Le Vigne Luciano Sandrone 1996
Seppelt Riesling 1984 Eden Valley (Australia)
Ridge Vineyards Monte Bello Santa Cruz Mountains (California)
Bodegas Riojonas Vine Albina 1942 Ryoca (Spain)
Château Angelus Saint-Emilion
Cheval Blanc 1947
Domaine Louis Croze Hermitage
Château Leoville las Cases Saint-Julien
Château Haut Brion 1989
Castello di Fonterutoli Siepi 1997
Roggio del filare Rosso Piceno 1995 Ercole Velenosi
La Grande Dame Rosé 1988 Veuve Cliquot
Barolo Bricco Rocche Ceretto 1989
Montevetrano 1993 Silvia Imparato
Barolo Serralunga Ceretto 1971
Château Cheval Blanc 1985
Lamaione Merlot di Castelgiocondo Montalcino 1997
Rosso di Montalcino Salicutti 1999
Clint Wilsey Mondavi Wines
Semillon 1996 Penfold's Barossa Valley (Australia)
Quinta do Carmo 1996 Alentejo (Portugal)

It is well to remember
— that there are
five reasons for drinking:
the arrival of a friend;
one's present or future thirst,
the excellence of the wine;
or any other reason . . .

LATIN SAYING
John Surmond, 17th century